IMAGES
of America

AVON LAKE

IMAGES
of America

AVON LAKE

Gerry Vogel for the Avon Lake Historical Society
and the Avon Lake Public Library

ARCADIA
PUBLISHING

Published by Arcadia Publishing
Charleston, South Carolina

Printed in the United States of America

Library of Congress Control Number: 2011924848

For all general information, please contact Arcadia Publishing:
Telephone 843-853-2070
Fax 843-853-0044
E-mail sales@arcadiapublishing.com
For customer service and orders:
Toll-Free 1-888-313-2665

Visit us on the Internet at www.arcadiapublishing.com

*This book is dedicated to the memory of John Robertson (1924–2011).
Past president of the Avon Lake Historical Society, John also played
many roles in the community, as you will see in the following pages.
His example of perseverance inspired me to finish this book.*

CONTENTS

ACKNOWLEDGMENTS

Over the past three years, the Avon Lake Public Library and the Avon Lake Historical Society (ALHS) collected, scanned, and returned thousands of photographs and documents from businesses, organizations, and individuals.

The society's historian, Nancy Nelson Abram, provided invaluable feedback, encouragement, and knowledge of key topics. Most ALHS members contributed photographs to the project and helped spread the word.

At the library, director Mary Crehore, graphic designer Kathy Diamond, and adult services associate Nadge Herceg deserve special mention. Support from the entire staff and board of trustees made this possible.

Thanks to Gerry Paine for support, feedback, and for finding donors; John Early and members of Avon Lake Landmark Preservation Society; William Barrow and his staff at the Michael Schwartz Library at Cleveland State University, especially Kiffany Francis and Joanne Cornelius; the City of Avon Lake, especially Mayor Karl C. Zuber, engineer Joseph Reitz, former recreation director Alexandria Nichols, and police chief David Owad; Avon Lake Community Television, especially Fran Fisher and Patty Green for making the "Avon Lake Life" oral history project happen; William Mann at GenOn's Avon Lake Station; Thomas Patton and staff at Commerce Group; Avon Lake City School District; Christ Evangelical Lutheran Church; Avon Lake Presbyterian Church; Avon Lake United Church of Christ; Lake Shore Methodist Church; Calvary Baptist Church; and Holy Spirit Catholic Church.

Thanks to all the following donors, loaners, and providers of clues: Sheila Barnes, Debra Beard, Paul Beck, Linda Bell, Shirley Blaser, Bob Bolen, Dan Brady, Bill Burmeister, Gretchen Burmeister, Glendalee Burns, Charlotte Carlson, Judy Cole, Ruth Copeland, Ron Davidson, Diane DeChant, Marlyn Diffenbaugh, Joseph Duber, Jean Foutz, Nancy Frey, Tom Gaston, Laurence Gates, Vicki George, Gary Gerrone, Rosemary Gfell, Phillip Glenn, Joan Grellinger, Teri Guggenbiller, Bud Haag, Josephine Hamilton, Ruth and Bill Higgins, Noel Ilg, Kathy Januska, David and Susan Jarzen, Jack Kinsner, the late Barney Klement, Doris Klement, the Klingshirns (Norm, Marie, Allan, Barb, and Lee), Herman "Bucky" Kopf, Kathi Krause, Fritz Kuenzel, Hans and Judy Kuenzel, Dennis Lamont, L. Francis Lott, Bob Marimon, Harvey Miller, Glenda Nelson, Jean Nowak, James and Mark Ouelette, Drew Penfield, Marilyn Pressnell, Jill Ralston, John Runyon, Dennis Schuster, John Shondel, Andrew Sopko, Beverly Stives, Alfreda Taylor, Robert Tomanek, Richard Turner, Jan Van Wagner, Jean Waller, and Richard Walz.

Melissa Basilone at Arcadia Publishing, you will be missed; Lisa Vear, thanks for your patience.

My wife, Victoria, my daughter, Lorelei, and my mom and dad: I love you all so much.

As with all other Arcadia Publishing titles, this book is driven by representative photographs selected for quality, relevance, and subject. These photographs must also fit within the space allotted. Photographs of a quality suitable for publication were simply not available of everything and everybody.

The full stories behind the photographs are too complex to relate in a short caption. For far more comprehensive and detailed accounts of the events, people, and organizations that made Avon Lake, see pages 126 and 127. The facts behind the photographs, dates, numbers, locations, and names come from these sources, as well as directly from the donors, interviews, unpublished correspondence, and ephemera. Sources do not always use the same terms of reference or agree in every case, but what we present is believed to be accurate based on available information.

The names of streets, buildings, organizations, and businesses not only change over time but are not always agreed upon, which includes how they are spelled. Names used in this book are contemporary with the photographs, and we follow the most common usage in sources.

Photographs courtesy of the Cleveland Press Collection of the Michael Schwartz Library, Cleveland State University, are abbreviated CSU.

INTRODUCTION

Thousands of years ago, the land comprising present-day Avon Lake and surrounding communities was under water, as melting glaciers left a series of ridges where ancient shorelines used to be. The most northerly of these follows present-day Detroit Road. Here, Native Americans settled, traded, fought, made peace, and eventually moved elsewhere. French and English colonial powers did the same.

Following a series of treaties, the area was purchased by the Connecticut Land Company in 1795 as the Western Reserve. Pierpont Edwards, in turn, purchased Tract No. 7 in 1807. Cuyahoga County was formed, and the territory comprising present-day Avon, Avon Lake, Bay Village, and Westlake was called, by the settlers who followed, *Xeuma*, a Native American term roughly meaning "those who came before us."

Noah Davis, the first lakeshore dweller, came in 1812 and lived in a three-sided cabin near the present-day intersection of Lake and Moore Roads for about a year. Wilbur Cahoon, who owned the land, encountered Davis and settled farther south (on Davis's advice), in the French Creek area where it was not as marshy but more suitable for farming, in 1814.

In 1818, Cuyahoga County drew new boundaries, splitting Xeuma in two. Dover Township was to the east, and Troy Township was to the west. Adam Miller and his family arrived in 1819, and they have been here ever since. The Millers and others who followed mostly cleared land, sawed timber, and built ships in nearby Black River (later renamed Lorain), however, Avon Lake's shoreline also had several sawmills and shipyards.

Lorain County was formed in 1822, and Troy Township was renamed Avon by petition in 1824. Settlement was still mostly in the southern part of the township. It took northern township residents two days to get crops to market because of the swampy conditions and the lack of good roads, making a detour through the easterly Dover Township (present-day Westlake and Bay Village) necessary. Drainage ditches were dug, and Center Road (today's Avon Belden Road and Ohio Route 83) was laid down with corduroy logs.

The New York, Chicago and St. Louis Railroad (soon known as the Nickel Plate) pushed through the middle of the township in 1882, neatly dividing it in half.

Meanwhile, in the northern portion, the soil and climate best suited vineyards, orchards, and berries. These profitable crops improved land values and the relative fortunes of lakeshore dwellers, many of them recent immigrants from similar growing regions in Europe.

By the 1890s, early settlers were three generations deep. In the late 1890s, the Lorain and Cleveland Electric Railway began building—just south of Lake Road—an interurban streetcar line, as well as a station, carbarn, and powerhouse. A series of transactions turned this into the Lake Shore Electric Railway (LSE) in 1901, ultimately linking Cleveland to Detroit and, through other lines, much of the Midwest. Passenger and freight traffic were now cheap to move at high speeds.

Streetcar lines, power plants, and amusement parks, which were popular destinations on weekends and holidays, always went together and were usually owned by the same company. All three came together at Beach Park. Tourists and another wave of settlers coexisted with vineyards and cows.

As early as 1908, the LSE was granted a franchise by Lorain County to build a waterworks, lay miles of water mains to spur development, and "father a city" in a location convenient to surrounding settlements, according to a contemporary *Norwalk Reflector* article. This would not happen as planned and not for some time. Regardless, northern Avon Township dwellers found their southern neighbors were not supportive of these public works, which did not benefit them. In 1910, a group petitioned for secession, but it took until 1915 to gain independence, and prior to this, some bitter boundary disputes had to be settled by the county.

In the end, the Nickel Plate became the line between the new townships, which went on to become villages and, later, cities. The first council of the new village of Avon Lake, which has also been known as Avon-on-the-Lake, was formed in 1917.

Beach Park was purchased by the Cleveland Electric Illuminating Company (CEI) and was closed down following a decline in crowds and a fire that destroyed the powerhouse in 1925. But cabins, camps, and cottages were already established at every stop. Housing developments competed for space with the vineyards, and land prices soared. A huge new power plant and waterworks went up where picnickers once frolicked, as Avon Lake, knowingly or not, prepared for a future as a commuter's refuge and an industrial dynamo.

Then the Great Depression arrived, damping the land rush. Another blow was the LSE shutdown in 1938. Better roads, a growth in car ownership, and regular bus service hastened the demise of the interurban age. The landscape was about to shift once more, but the shadow of LSE persisted. For many decades, stops were still used to identify locations along Lake Road, from east to west and from Stop 39 at the Bay Village-Cuyahoga County line to Stop 70 at the Sheffield Lake line (see page 100).

After the war, the village attracted Fruehauf Trailer Company and the B.F. Goodrich Company, which were drawn by convenient and affordable transportation, water, power, space, and a capable workforce largely composed of returning GIs. Having changed hands and purposes over the years, these giant plants have continued to grow and are still here today. The plants made property taxes very low for home owners, and the population started doubling every decade. Hundreds of new homes, businesses, schools, streets, and water and sewer mains meant lots of construction work.

With a population of just over 9,000, Avon Lake became a city in January 1961. It has become a larger city since then, but not as large as once forecasted. This is because the course of growth and development changed yet again. Interstate 90 was completed in the late 1960s and took most traffic, in addition to future industrial and commercial developments, well south of the Nickel Plate (now Norfolk-Southern) tracks. Lake Road is mostly a scenic byway today.

Nevertheless, new families continue to discover Avon Lake and put down roots next to neighbors with six or more generations of stories to tell.

One

YESTERDAY'S HOMES
AND NEIGHBORS

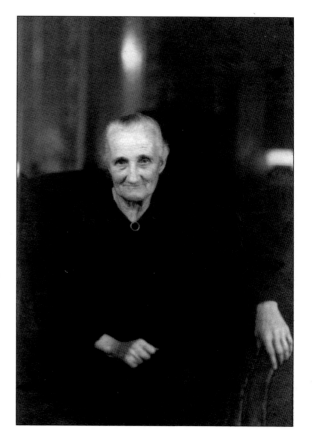

"GRANDMA" TOMANEK. Some people go to new places and decide to stay for many reasons. Many people who stay after arriving at their destinations do so because these areas encompass the meaning of home in every sense. Pictured around 1935 is Clara "Grandma" Tomanek, who, for a long time, was the oldest resident of Avon Lake and known to all. Even in her 80s, she walked from her home at 31941 Lake Road four miles west and back to pay her water bill. (Courtesy of Robert Tomanek.)

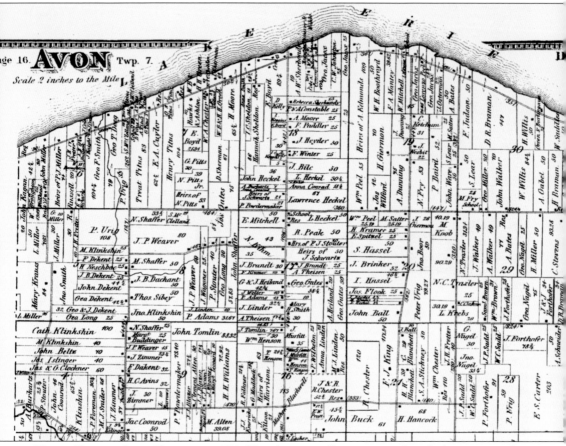

NORTH PART OF AVON TOWNSHIP, 1874. The plats, as well as streets and roads, have names that belong to many families still here, but some have unfamiliar spellings. There are no railroads yet. The main west-to-east routes shown are still Lake and Walker Roads, while north-to-south routes are, from left to right, Miller, Moore, Center, Jaycox, and Lear Roads. Center Road has also been known as Avon Center Road, State Route 76 (until 1972), Avon Belden Road, and State Route 83. (Courtesy of *Lorain County Atlas*, 1874.)

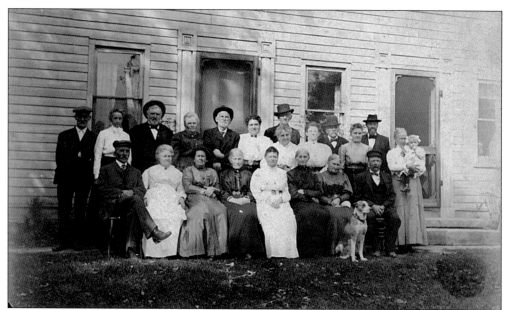

THE MILLER FAMILY IN FRONT OF THE PETER MILLER HOUSE, C. 1910. Adam Miller was the first permanent settler in present-day Avon Lake. He arrived with his family from New York State in 1819, and his youngest son, Peter, built this house around 1830. Here, family and friends pose in front of the house. (Courtesy of Gerry Paine.)

THE TITUS HOUSE, 33350 LAKE ROAD. Built in 1847 by pioneer educator Anson Titus, this early Greek Revival home is also known as the Cuyler-Curtis house after descendants who kept it in the family. Anson also built the first schoolhouse in northern Avon Township. This house is still occupied and can be found next to the present-day waterworks of Avon Lake. (Courtesy of Gerry Paine.)

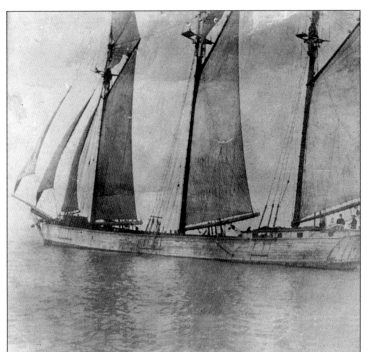

SCHOONER *C.B. BENSON*. Early settlers, who all farmed (mostly out of necessity), also built ships and sailed them, too. Many Avon families, even today, were lake and seafarers. Built by Capt. John Duff in Port Clinton in 1873, *C.B. Benson* made one of the first voyages through the Welland Canal, traveling to Ireland and back. The ship sank in Lake Erie—south of Port Colborne, Ontario—in 1893, and seven perished, including Captain Duff and first mate Curtis Duff. (Courtesy of Gerry Paine.)

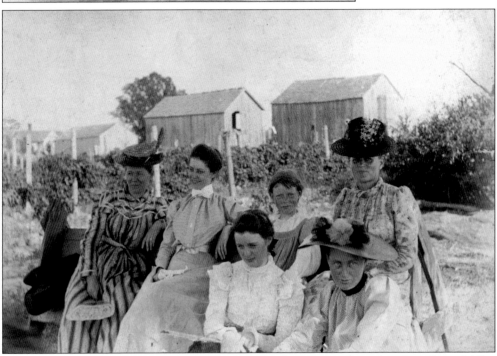

THE DUFF FAMILY IN THE VINEYARD, C. 1900. In the first row on the right side is Carrie Miller Duff, the widow of Curtis Duff Sr. She was expecting their son, who was also named Curtis, when her husband perished in the sinking of *C.B. Benson*. Directly behind her is Jane Cuyler Curtis, a granddaughter of Anson Titus and, like him, a schoolteacher. She wrote an early historical sketch of Avon Lake in the mid-1920s. (Courtesy of Gerry Paine.)

Lear Family at Work, 1908. John and Mary Lear make spring flower beds on their homestead at 309 Lear Road. John's father, Sebastian Lear, had settled in the easterly part of the township in 1848. John was one of the founding councilmen of Avon Lake. (Courtesy of Marlyn Diffenbaugh.)

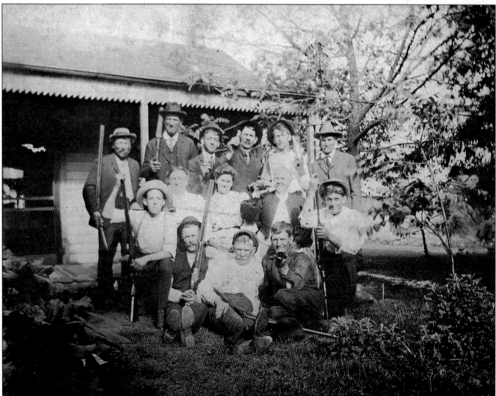

The Lear Homestead, 1909. Pictured are members of the Avon Gun Club. Erwin Lear, the son of John and Mary Lear, is in the second row on the right. The family's last name was often spelled "Loher" or "Lehr" until the early 1900s. (Courtesy of Marlyn Diffenbaugh.)

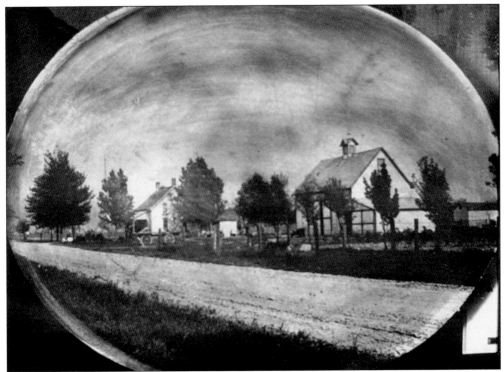

SATTER FARM, WALKER AND JAYCOX ROADS. Michael Satter purchased this property at the corner of Jaycox and Walker Roads in 1857, and the farmhouse was likely built by him. It later served as a winery, granary, combination gas station and grocery, tavern, and dance hall. This picture was likely taken around 1890. (Courtesy of Thomas Patton.)

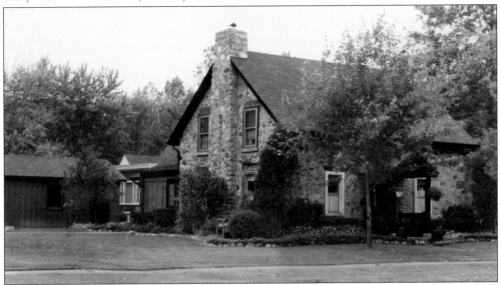

A STONE HOUSE, 32295 WALKER ROAD. Through the years, 13 different families owned the Satter farm. In 1967, Hans and Judy Kuenzel purchased the property and spent the next two decades restoring the stone and wood construction while modernizing plumbing and electrical wiring. This picture was likely taken around 1980. (Courtesy of Nancy Abram.)

THE JOHN WALKER HOUSE, 31860 WALKER ROAD. John Walker built this home with his brother in the late 1840s. He was also responsible for building a log schoolhouse on his property around 1850. (Courtesy of Nancy Abram.)

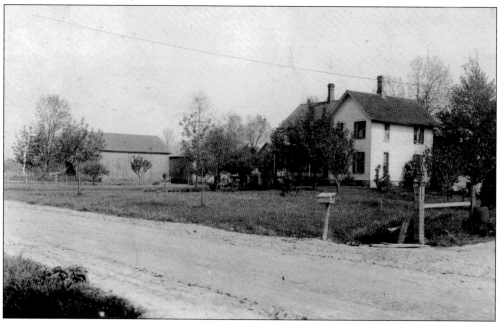

ALFRED JOHN WALKER SR. FARM, 31941 WALKER ROAD. This home was built in the 1880s on the southern side of Alfred John Walker's father's namesake road. Alfred's grandsons, Walter and Foster Schenk, started an apple orchard here in the 1920s, which became Smotzer's Orchard after they retired. John Walker's log schoolhouse had been moved across the street, and the Schenks used it as a garage for many years. (Courtesy of Nancy Abram.)

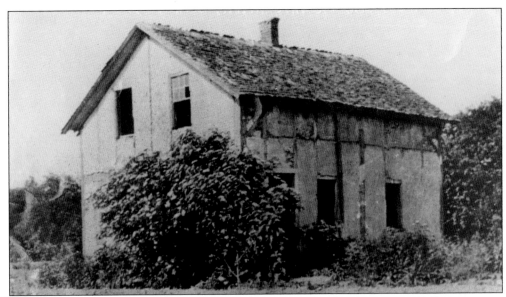

THE GATES HOME, EARLY 1900s. The John Goetz family arrived in America in 1847, just in time to be stricken with cholera. Son George purchased land west of Center Road and built this stone house in the 1860s on the present-day Sweetbriar Golf Course. George's son Gerves was born in the house, which was later used as a shed for berry picking. Gerves continued to raise grapes and berries and built houses, too. He built two homes from kits, which were from Sears and Aladdin, on Center Road for his own family. (Courtesy of Laurence Gates.)

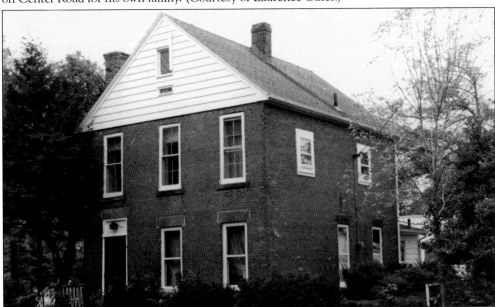

SISSON HOME, CENTER ROAD, LATE 1970s. In early township days, the distinctive redbrick trademark (seen here at the Sisson home built in 1872) belonged to the Heiland brothers. The brothers owned a brickwork firm and construction company. They built Avon Town Hall, St. Mary's Church, and many of the homes and schoolhouses in the area. Many of the bricks came from a pit on this property, which became a pond that was filled in much later. (Courtesy of Nancy Abram.)

THE KREBS-ABRAM FAMILY HOME, C. 1940. Henry Krebs built this house in 1842 and expanded it after the Civil War. Maynard G. Krebs was born in this house in 1899, and it remained in the family for a century. Joseph Abram purchased the home in 1945, and they added porches. A blacksmith shop still stands on the south corner of the property, next to Center Road. (Courtesy of Nancy Abram.)

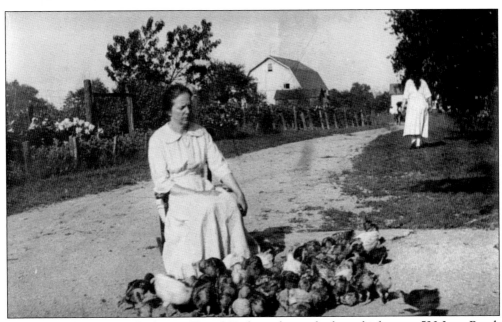

KREBS FARM, C. 1900. Catherine Kinzel Krebs is shown feeding chickens at 520 Lear Road, just south of Walker Road on the west side. The farmhouse is in use today but is surrounded by development. (Courtesy of Vicky George.)

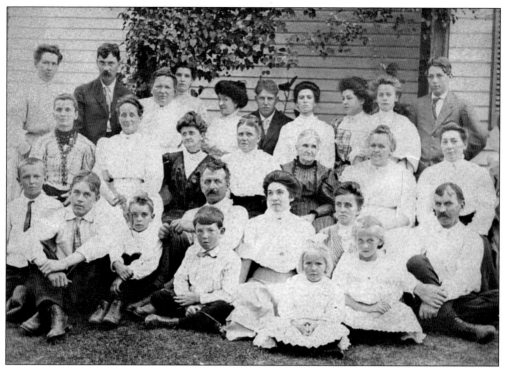

TITUS AND BEARD FAMILIES, C. 1908. This gathering took place in front of the old house, which was too close to the lake and has since washed away. (Courtesy of Debra Beard.)

CHARLES BEARD WITH HATTIE THE HORSE. This c. 1908 postcard shows Beard in front of the family homestead at 149 Moore Road, looking northeast. The LSE powerhouse is in the background. Hattie was known for racing LSE cars as they passed by. (Courtesy of Debra Beard.)

Gwen (Beard) Anderson and Chuck Beard. Gwen and Chuck (daughter and son of Charles Beard) are shown on their bikes in front of the family barn in 1934. The barn stood until 1975. (Courtesy of Debra Beard.)

The Biltz Home, 360 Center Road. This was the 1871 home of John J. and Cunigunda (née Heckel) Biltz. Their youngest daughter, Matilda, lived here until just before this photograph was taken 100 years later. Russ and Wendy Manternach, having just purchased it, found that no renovations had taken place since 1895 and that a natural gas well on property still lit and heated the house. Restoration has continued ever since. (Courtesy of Nancy Abram.)

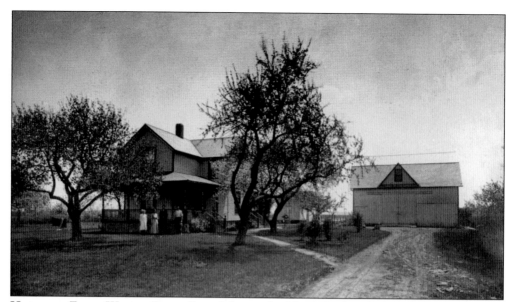

HORWEDEL FARM, WALKER ROAD. From left to right, Meryl, Ruth, Julia, and Charles Horwedel pose in front of their homestead built in 1912. Former grocer John Christ bought the property in 1943 and established a winery that still bears his name. His son Alex greatly expanded operations, and it continues to attract visitors. (Courtesy of Vicki George.)

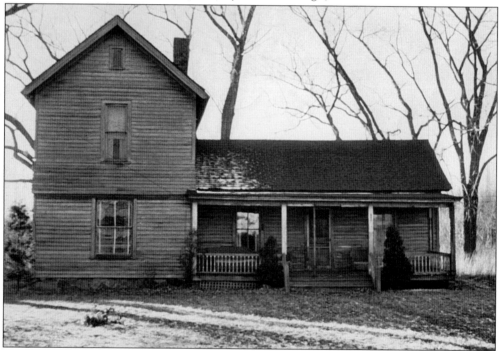

THE DUNNING HOME, 1958. Alexander Dunning's family settled on 100 acres on the corner of Jaycox and Walker Roads in 1851. His grandson Charles Ernest Dunning lived in this house at 240 Jaycox Road, which was built in 1853 and expanded in 1904. Nina Dunning and her twin sister, Nettie, were born here in 1893. Charles, who preferred the name "Ernie," was the very first village clerk, and Nina was the third. She did most of her work from this home. (Courtesy of CSU.)

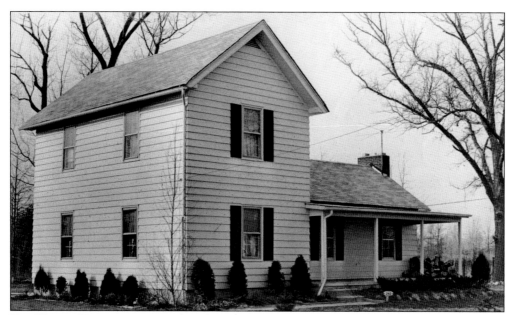

THE HOBAR HOME, 1964. Frank and Veronica Hobar purchased the Dunning home in 1958 and began restoring and updating it inside and out. It was featured, with many photographs, in a 1964 *Cleveland Press* article on renovating older homes. (Photograph by Paul Tepley; courtesy of CSU.)

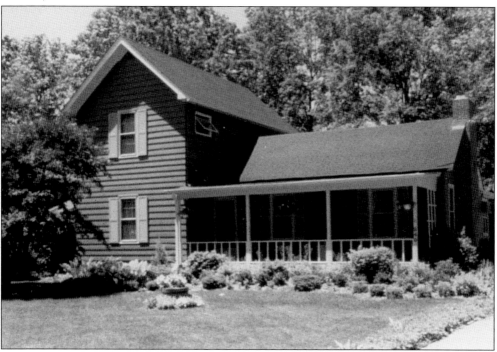

THE BURNS HOME, 1978. Tom and Glendalee Burns purchased 240 Jaycox Road in 1974 and completed the careful process of updating and restoring it. Later on, they extensively added to the back of the house, but it still retains its character today. The *Cleveland Plain Dealer* featured the house in a special section in 1979. (Courtesy of Glendalee Burns.)

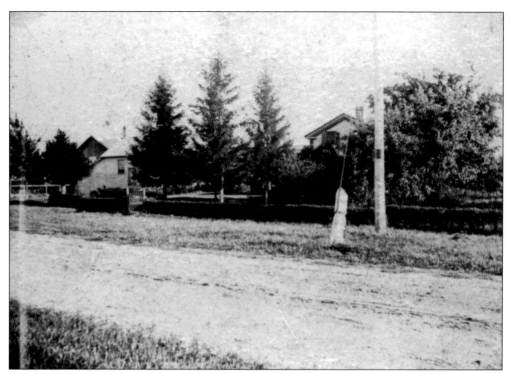

THE BECK HOMESTEAD. Located near a prominent and hazardous kink on Lake Road—close to present-day Coveland Drive—the Beck homestead is shown here in October 1898. The bend was straightened out a few years later. (Courtesy of Paul Beck.)

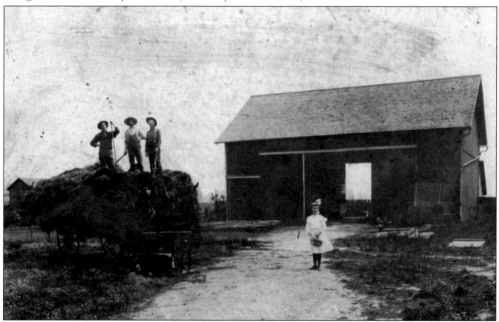

BECK BARN, C. 1900. This frame barn was also accessed from family-named Beck Road, which is still one block east of Jaycox Road. Pictured standing on the hayrick on the far left is Fred Beck. His sister Amelia is shown in front of the barn. (Courtesy of Paul Beck.)

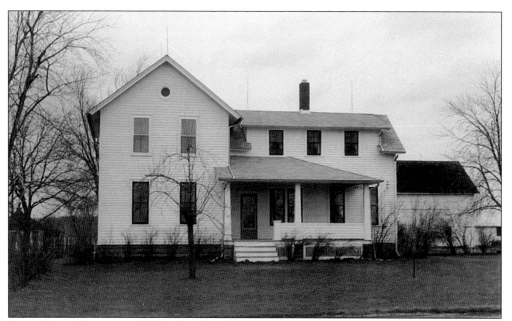

THE ANTON KLINGSHIRN HOMESTEAD, 1940s. This house, located on Walker Road, was built around 1878. It was later the home and farm of Anton Klingshirn's son Roman. (Courtesy of Barbara Klingshirn.)

KLINGSHIRN FARM, 33050 WEBBER ROAD. Albert, another son of Anton Klingshirn, purchased this farm in 1922, and this photograph was taken shortly afterward. Alex and Wiley Anderson were the original owners of the house around 1858, and Albert was the sixth. His son Allan purchased the home in 1955 and lives there, next to the family's winery, today. (Courtesy of Barbara Klingshirn.)

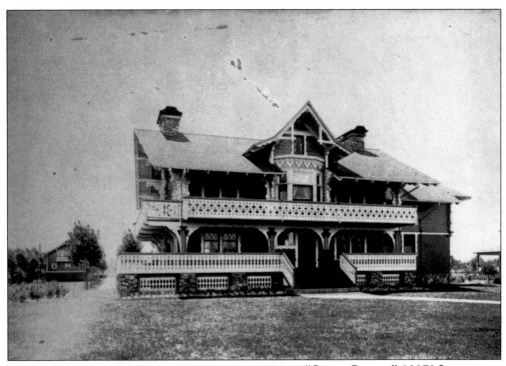

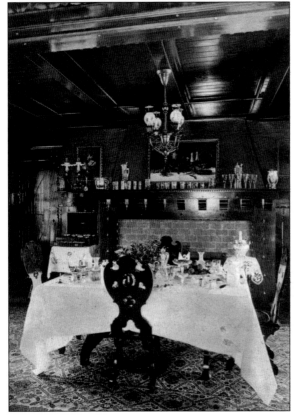

"Green Gables," 32972 Lake Road. In 1898, Cleveland brewer James Gehring built this distinctive house and matching barn-coach house as a summer estate. It was sold to James Griffith, a maker of brass plumbing fixtures, in 1919 and then to meat packer Charles Hildebrandt in 1934. The photograph above is a view from the lake. Shown at left is the dining room. (Both, courtesy of Peter Miller House Museum.)

DeChant Family, 1932. Pictured here are, from left to right, Edward F., Philip, Edward William (father), Richard, Florence (née Buswell, mother), Woodrow, and Richard DeChant at their Miller Road home with wooden sidewalks. Florence was Avon Lake's first female postmaster in 1931, serving for 26 years in locations on the east and west sides of town. Edward Sr. was first a village councilor, then a county commissioner, and, finally, a state representative from 1950 to 1966. (Courtesy of Diane DeChant.)

Heider Family, 1935. Anna Mary and Leo G. Heider, with daughters Marjorie (six years old) and Ruth (one year old), are shown behind their home at 269 Center Road. Leo was a motorcycle patrolman, and Anna was the first and only employee of the nearby Avon Lake Public Library when it opened in 1931. The DeChants, shown in the previous image, were neighbors, and their lands later became athletic fields for the high school and the Washington Square subdivision. (Courtesy of Ruth Heider Copeland.)

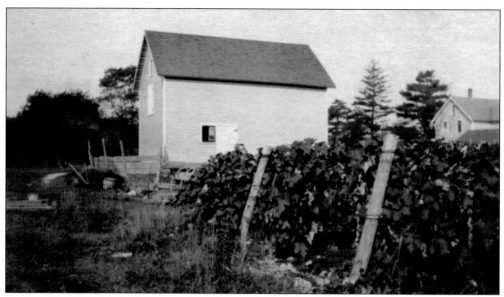

HEIDER BARN AND VINEYARDS, C. 1935. Leo Heider's grandfather John Heider Sr. settled in the area before the Civil War and built a house at 303 Center Road, just south of present-day Redwood Boulevard. Heider Creek is named for the family. Besides cultivating 20 acres of grapes, Anna Mary designed and Leo built a bungalow on their land at 279 Center Road. (Courtesy of Ruth Heider Copeland.)

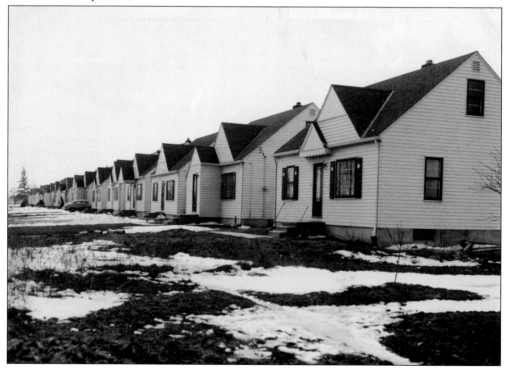

MOORE ROAD, 1949. Looking south from approximately Charleston Avenue, homes on the west side of Moore Road are nearing completion. Until the late 1940s, this was Steve Moore Road. (Photograph by Glenn Zahn; courtesy of CSU.)

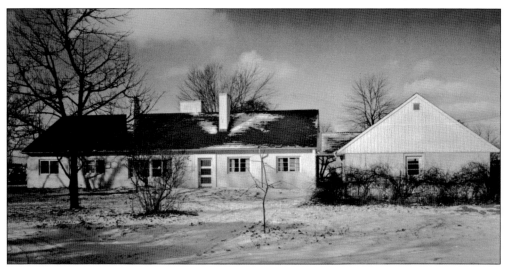

LAKE HOUSE, 33756 LAKE ROAD. Viewed from the south, this innovative home for the Horsfall family was built on part of the family farm in 1947. Designed by Miller and Voinovich and constructed by Robert Baerwald, it was built of locally made concrete blocks (Geistone) and had concrete floors and metal door and window frames. The double exterior walls use an air space for insulation, and radiant heat is piped throughout. (Courtesy of Linda Horsfall Bell.)

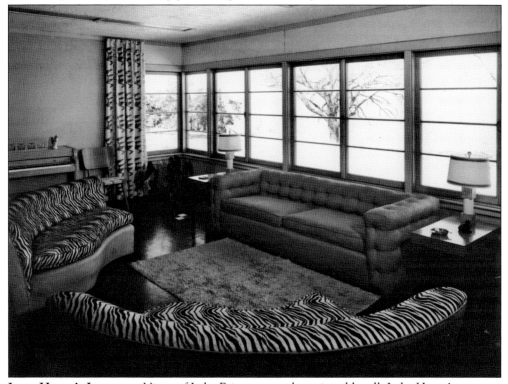

LAKE HOUSE'S INTERIOR. Views of Lake Erie can now be enjoyed by all. Lake House's property was purchased by the city in the 1990s to expand Veterans Park, and the home serves today as a community hall that is available for public meetings and private events. (Photograph by R. Marvin Wilson; courtesy of Linda Horsfall Bell.)

INWOOD BEACH CLEARING, EARLY 1940s. The Yoder Construction Company was the first to begin work on Avon Lake's first modern subdivision. It was subdivided to several developers and construction companies after that. A building boom was coming, however, it would not take off until after the war. The village's population went from 2,627 in 1941 to 4,793 in 1952. (Courtesy of Thomas Patton.)

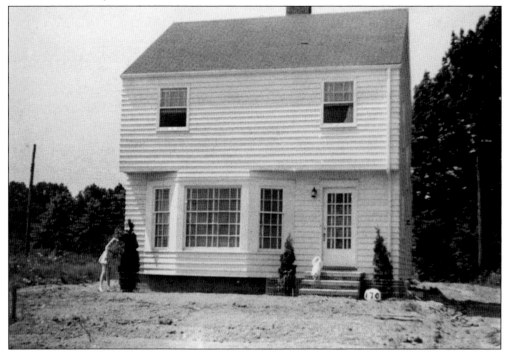

INWOOD BOULEVARD, 1947. The Glenn family inspects their new home at 170 Inwood Boulevard, one of the first completed in the subdivision. A yard and neighbors behind them (on Berkshire Road and to the west) are still years away. Alonzo, who preferred his middle name, "Lionel," Glenn was an attorney and Avon Lake's law director for four years. (Courtesy of Phillip Glenn.)

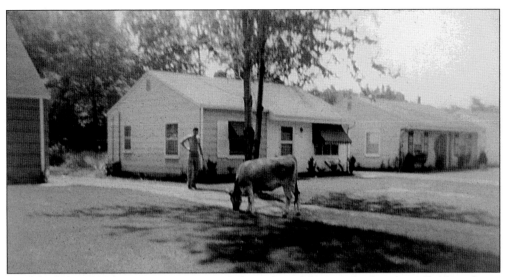

SUBURBS MEET FARMS, 1952. George Amolsch confronts a cow in the driveway of his brand-new home at 310 Dellwood Avenue. The cow escaped from a farm on nearby Curtis Drive, a common occurrence in the growing city. (Courtesy of Doris Amolsch.)

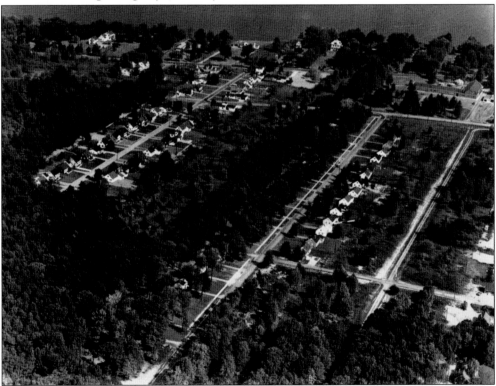

INWOOD BEACH AREA, AERIAL VIEW, 1953. This image is looking north toward Electric Boulevard and Lake Road, with St. Joseph Church and School in the top left corner. From left to right, the north to south streets are Parkwood Avenue, Fairfield Road, and Berkshire Road, which is still incomplete. Beachwood Avenue would later appear between Parkwood Avenue and Fairfield Road. (Photograph by Robert Runyan; courtesy of the Bruce Young Collection at CSU.)

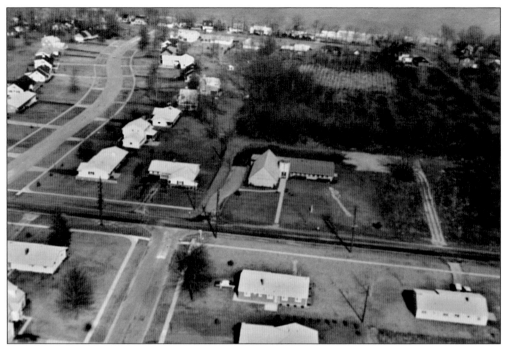

AERIAL VIEW, LOOKING NORTH, C. 1963. Well east of Center Road, the land fills with new construction by the late 1950s. On the left, new houses on Harvey Parkway wind between Electric Boulevard and Lake Road. Also visible is the north end of Yoder Boulevard and Avon Lake Presbyterian Church. (Courtesy of Avon Lake Engineering Department.)

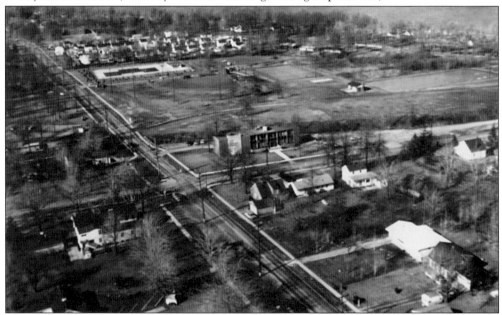

AERIAL VIEW, LOOKING NORTHWEST, C. 1963. The corner of Electric Boulevard and Center Road is in the middle, with city hall visible in front of Heider Creek. It is clearly wintertime since there is little foliage and an ice rink is visible in the north part of Bleser Park. Beachdale and Woodstock Drives are in the foreground on the right. (Courtesy of Avon Lake Engineering Department.)

THE SPEIGLE HOME, 1950. Here, Paul and Hermaine Speigle are building their dream home at 366 Center Road, where they raised three young children (pictured in the windows) and lived until 1987. Hermaine was Avon Lake's first Avon Lady (representative for the cosmetics company) and wrote for the *Lorain Journal*. Inspired by daily life on the suburban frontier, she also wrote poetry. *Pop Concert: A Novelette in Verse* collects her observations from the period. (Courtesy of Kathi Speigle Krause.)

OUELETTE FAMILY, 1967. Pictured are, from left to right, Neal, Marie, Paul, Mark, James, and John Ouelette behind their farmhouse at 270 Moore Road, looking north with CEI's Avon Lake station in the background. The house was torn down in 1971, but it was notable for being built by settler Peter Urig in the 1820s and owned by Avon Lake mayor Lynus Rupert in the 1950s. (Courtesy of Mark Ouelette.)

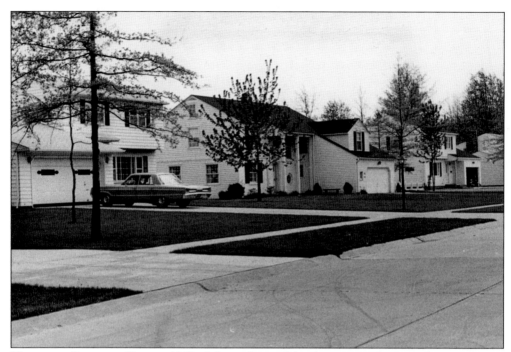

HOMES ON GLENVIEW DRIVE, 1967. A later phase of development took place closer to Center Road. By now, developers offered larger lot sizes and buried utilities. City council passed ordinances mandating 100-foot frontages. (Photograph by Clayton Knipper; courtesy of CSU.)

MAPLE CLIFF DRIVE, 1967. Looking north from Lake Road toward the lake and across from Erieview Elementary School, this street and the parallel Gra-Gull Drive are located on some of the most northerly land of Avon Lake's shoreline—notwithstanding Avon Point and North Point. (Photograph by James Thomas; courtesy of CSU.)

Two

TAKING CARE OF BUSINESS

GLENN BEARD AND HIS VINEYARDS. Agriculture, commerce, and industry have always been close neighbors in Avon Lake. Pictured around 1960, Glenn Beard works his vineyards on the west side of Moore Road under CEI's high-tension wires. (Courtesy of Debra Beard.)

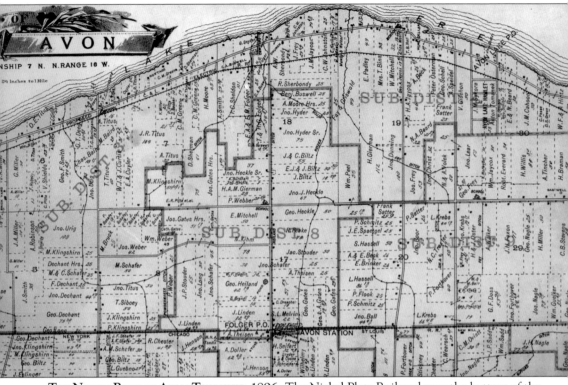

THE NORTH PART OF AVON TOWNSHIP, 1896. The Nickel Plate Railroad near the bottom of the map will form the future boundary of Avon and Avon Lake. As the divisions shown on the map indicate, this would be the source of future tension. The proposed electric railroad's path is shown south of Lake Road. Note that there is also a post office for Beach Park in the west part of the township. There is an Avon Lake hamlet where the present-day 45 district is located. (Courtesy of *Lorain County Atlas*, 1896.)

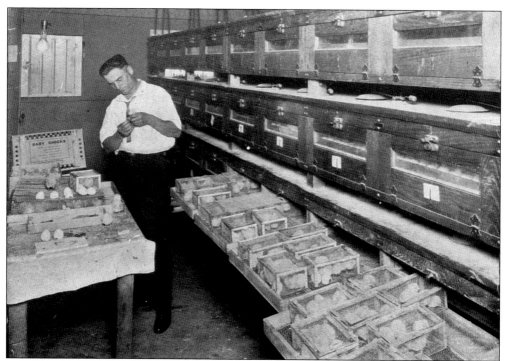

Puritas Springs Poultry Farm, 1926. Owner S.J. Schenk inspects and registers newly hatched chicks. Schenk's operation was near Stop 56 (Lake and Center Roads), and he shipped hatching eggs and chicks far afield. His farm's 1926 catalog invites buyers to come and see why they have the best single-comb leghorns. (Courtesy of Thomas Patton.)

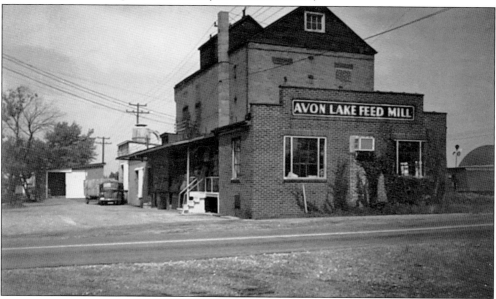

Avon Lake Feed Mill, 1940. Michael Klingshirn, the first son of Anton, opened this business in a building that was a store, a saloon, and probably the Folger Post Office. It was located just south of the Nickel Plate tracks in 1926. The office was added in front later on. Ironically named, the Feed Mill was always in Avon. (Courtesy of Barbara Klingshirn.)

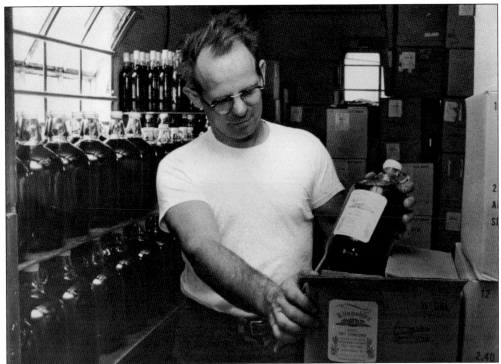

KLINGSHIRN WINERY, 1967. Allan Klingshirn boxes wine in the retail section of his family's winery. In 1955, the same year he married Barbara Jones, Allan took over the winery his father Albert established in his basement with help from his family and neighbor Curtis Duff Jr. in the 1930s. Allan and Barbara's son Lee runs it today. (Courtesy of Barbara Klingshirn.)

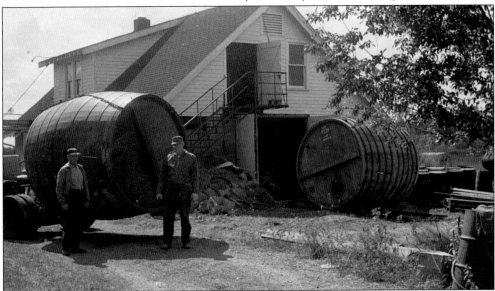

KLINGSHIRN WINERY, 1969. The building for the winery was erected in 1940, with expansions made as the business grew. Here, 2,000-gallon casks arrive from an old winery in Sandusky and are moved into the building with help from Allan's uncle Roman and brother Lawrence Klingshirn. (Courtesy of Barbara Klingshirn.)

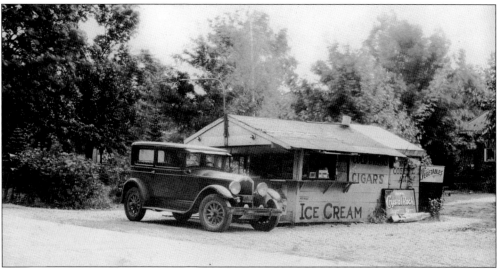

THE STAND, 1935. This unassuming fruit and ice cream stand on Lake Road has now been around for over a century. Here, it sits on land owned by the Tomaneks and, later, the Horwedels. (Courtesy of Barney Klement.)

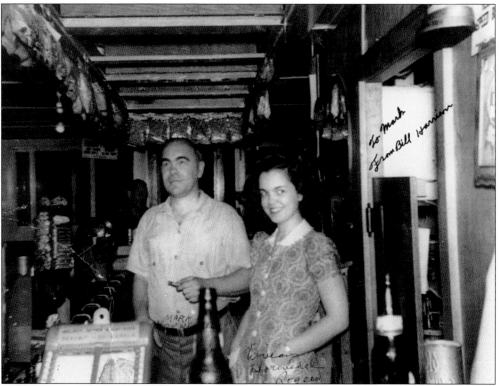

MARK'S PLACE, 31953 LAKE ROAD. The stand became enclosed and evolved into this store/tavern where drinks and food could be purchased. Pictured are owners Mark Horwedel and his daughter Vivian Horwedel Rogers in 1942. Today, the place is well known as Close Quarters because it has a maximum capacity of only 38 people. It is not the smallest bar in the world, but it's close. (Courtesy of Vicky George.)

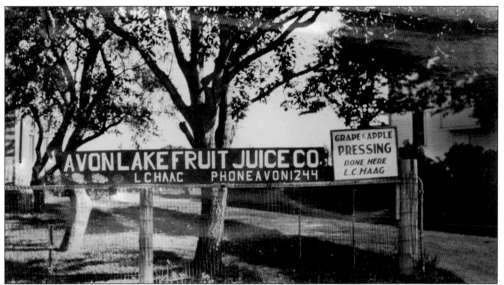

AVON LAKE FRUIT JUICE COMPANY, 1935. The Leonard Haag family not only had orchards and vines on the north side of Lake Road (Stop 43) but also had one of the area's largest juice presses. Son Carl kept up the tradition and also became the first full-time fire chief. (Courtesy of Barney Klement.)

DUFF PEACH BARN, 1940s. A onetime landmark and located across Lake Road from the Titus-Cuyler-Curtis house, this barn likely predates the house. Until 1856, Lake Road was a dirt path north of where it runs today, and the decision to move the route southward separated many homes from their barns. This barn was pulled down in the 1950s. (Courtesy of Gerry Paine.)

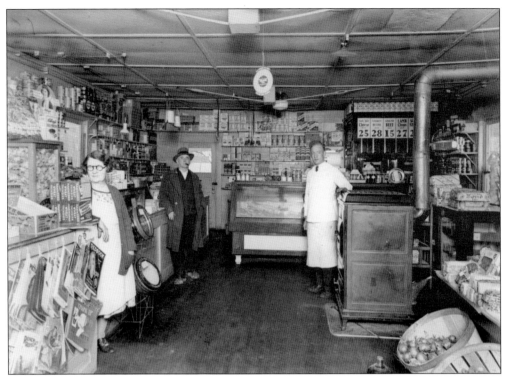

DERRENGERS (LATER, BARNES) STORE, STOP 65. Those pictured are, from left to right, then-current owner Bertha Derringer, Charles Beard (with cigar), and future owner Herb Barnes during the winter of 1930. Eventually, after a series of moves and new construction, Barnes's Store became Bob's Market and then the Sparkle Market. (Courtesy of Debra Beard.)

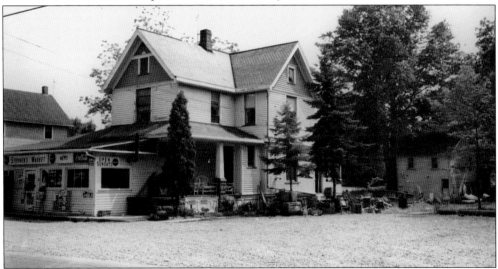

STEPHENS'S MARKET, C. 1955. Originally built by Eugene Hermann in 1895, this building, located at 32485 Lake Road and at the corner of Avon Point Road, was often called "Tourist Inn," as there were also rooms and cabins to rent. Much later on, it became Carol's Place, Harry O's, and Herb's on the Lake. Today, after significant renovation and reconstruction, it is called Jake's Lake House. (Courtesy of Avon Lake Police Department.)

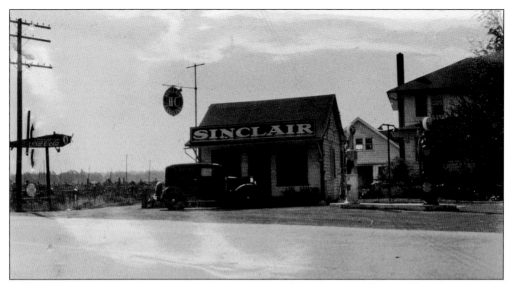

KEKIC'S GAS STATION, 31917 LAKE ROAD, C. 1929. Tade and Anna Kekic purchased 10 acres on Lake Road near Stop 43 in the 1920s. They opened the first gas station in Avon Lake in 1923, with the family of nine taking turns operating it. Kekic's was a local landmark known for its airplane, which was a replica of the *Spirit of St. Louis* that served as a sign and a weather vane. (Courtesy of Barney Klement.)

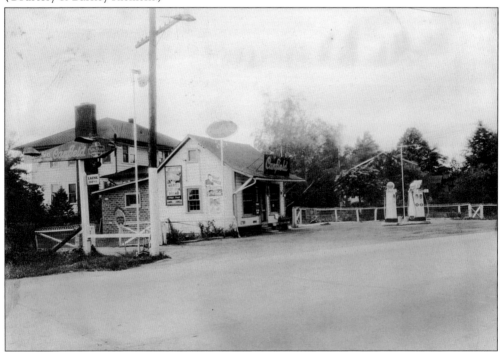

KEKIC'S, C. 1935. Here is a later view of Kekic's, which eventually became a Canfield station and then a Gulf and Marathon. According to a 1964 article in the *Lorain Journal*, the Coca-Cola Company distributed 150 of the airplanes around Ohio in 1928, and by far, Kekic's lasted the longest. The station persisted in Avon Lake until early 1994, but the airplane vanished shortly afterward. Its present whereabouts are unknown. (Courtesy of Barney Klement.)

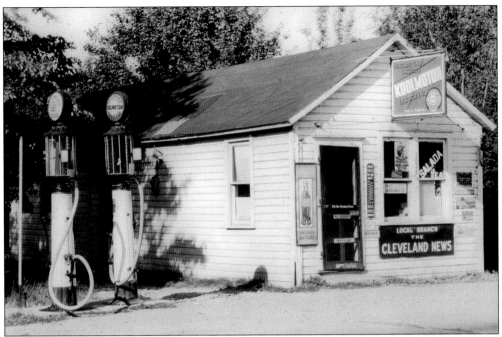

MILL'S STORE, C. 1935. There is some debate over the actual location of this store and gas station, but it was likely on the north side of Lake Road between Stops 56 and 63. Stores were known to move around and change names and ownership a lot. (Courtesy of Barney Klement.)

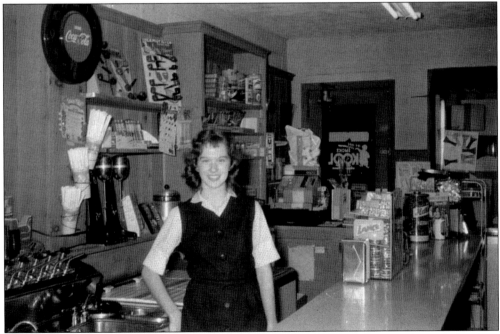

AVERY'S DRUGSTORE, 1958. Pictured is Susan Klein, who worked at this popular soda fountain for several years as a teenager. Located on South Point Drive, near Stop 45, it was owned by Betty (Avery) Hoagland, who inherited the business from her mother and passed it on to her daughter Glenda (Hoagland) Nelson. (Courtesy of David and Susan Jarzen.)

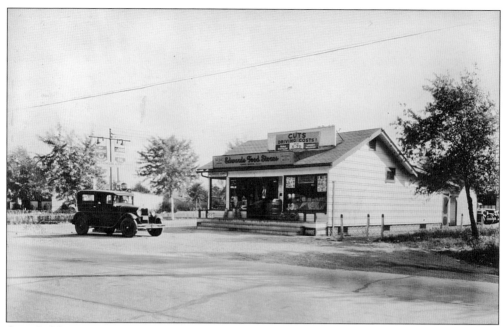

GANG'S MARKET, 32457 LAKE ROAD, C. 1935. First known as Edwards Food Store in 1915, this market was operated by the Gang brothers at the corner of Lake Road and Fay Avenue. Immediately behind it was Avon Lake Garage, which was owned and operated by the Kidney family. (Courtesy of Dennis Schuster.)

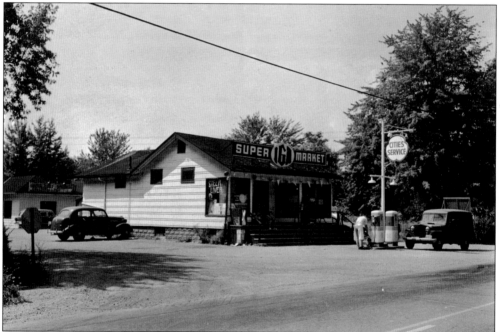

IGA, 1950s. The Gangs moved their business to the Lear Road area in the 1950s, where it was later purchased by Chuck Beard. This IGA moved in at Stop 52 and was operated by Chuck Lott, who later moved it to the Saddle area. Today it is the Avon Lake Wine Shop. (Courtesy of the City of Avon Lake.)

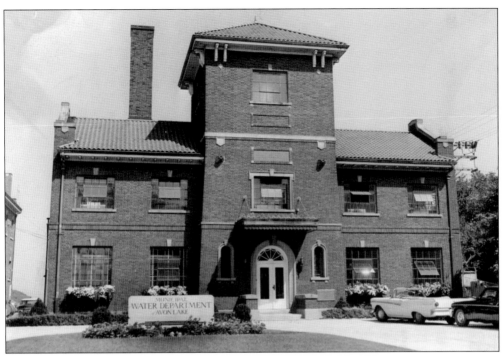

AVON LAKE WATERWORKS, 1958. The original plant at 33370 Lake Road was completed in 1926. It was built by the Lorain County Commissioners and then turned over to Avon Lake. It was paid off by the 1940s. The initial capacity of two million gallons per day was more than enough for the 1,200 residents of the time, but the plant was built to anticipate much further growth. (Photograph by Byron Filkins; courtesy of CSU.)

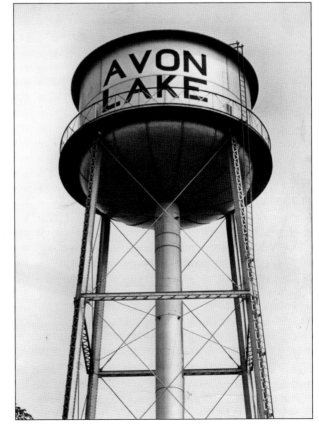

MUNICIPAL WATER TOWER, 1941. Capacity has since been expanded to 40 million gallons per day, and Avon Lake Municipal Utilities now supplies water to 180,000 residents in five counties. This early tower was located across Center Road from Avon Lake School and, thus, was a popular spot for graffiti. It became redundant with construction of new towers and was torn down in the 1960s. (Photograph by Fred Bottomer; courtesy of CSU.)

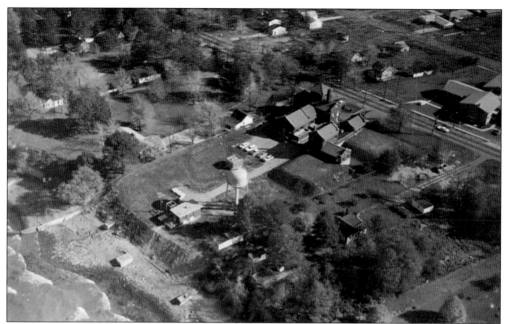

AERIAL VIEW OF WATER PLANT, C. 1963. This view is looking southeast from Lake Erie. Plant capacity was, by this time, four million gallons per day, and a new intake and pump stations had recently been built. The plant was already providing water to Avon and Sheffield Lake. The Titus house is just behind the trees east of the plant. Avon Lake's first apartment building is located at 33373 Lake Road. (Courtesy of Avon Lake Engineering Department.)

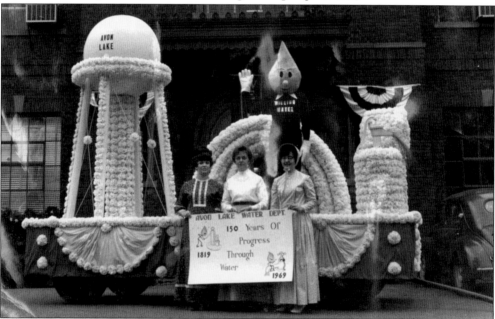

WATERWORKS' PARADE FLOAT, 1969. Here, an iconic Sesquicentennial Parade float is shown celebrating "Progress Through Water," with Fritz Kuenzel as "Willing Water," the smiling mascot. Capacity was now six million gallons per day, and large portions of Lorain and Medina Counties would be served by the mid-1970s. (Courtesy of Fritz Kuenzel.)

CEI Plant, Bridge Abutment, June 1925. This photograph documents the progress from June 1925, which includes the beginnings of a railway bridge over Lake Road that helped get coal to the plant. Note the sign, which reads as follows: "Avon Superpower Station, Ultimate Capacity 400,000 Horsepower." Confusion with Avon still made some local residents upset at that time. Today, locals are not upset by this anymore, but misdirection is still prevalent. (Courtesy of GenOn, Inc.)

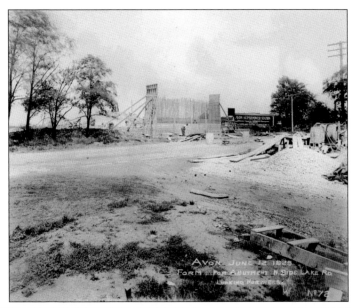

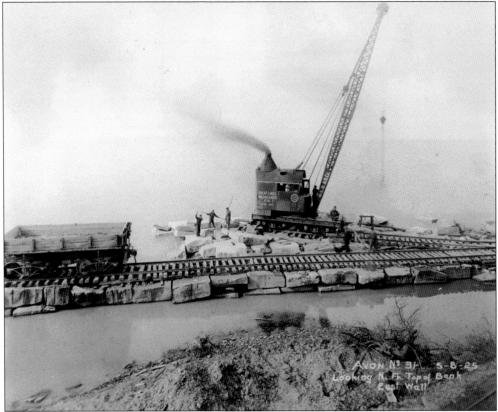

CEI Plant, June 1925. Crews use steam-powered mobile cranes and flatcars to construct a breakwater to protect the plant's water intake. The crews deposit stone and lay rails to deposit more as they go. The wreck of a crane barge used in the construction still lies off the end of the breakwater. (Courtesy of GenOn, Inc.)

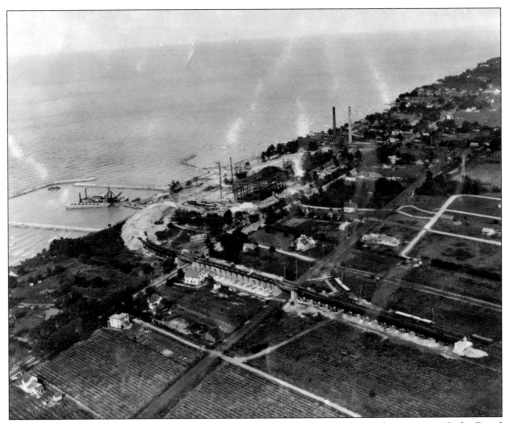

AERIAL VIEW OF CEI CONSTRUCTION, SUMMER 1925. The bridge for coal trains over Lake Road is finished, but ramps north and south are still incomplete. Brickwork and stacks are not visible yet. The ruins of the old LSE power plant persist. (Courtesy of Gerry Paine.)

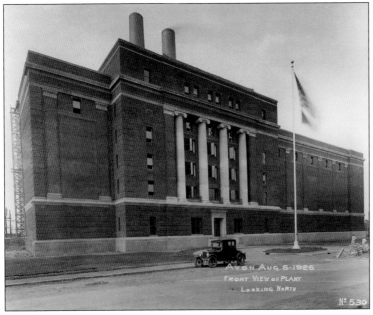

CEI FACADE COMPLETED, AUGUST 1926. Workers pause on Lake Road to admire the ornate plant entrance, looking north. Two, 25-megawatt units and stacks were operating that year, and two more were ready by 1928. The 50-megawatt Unit 5 was added in 1943. (Courtesy of GenOn, Inc.)

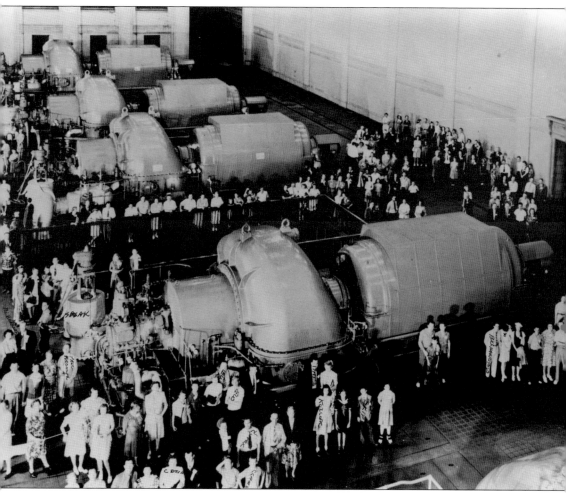

CEI Open House, c. 1928. Crowds gather on the floor of the turbine hall. Names have been written on this photograph over the years in an attempt to identify some of the participants. (Courtesy of GenOn, Inc.)

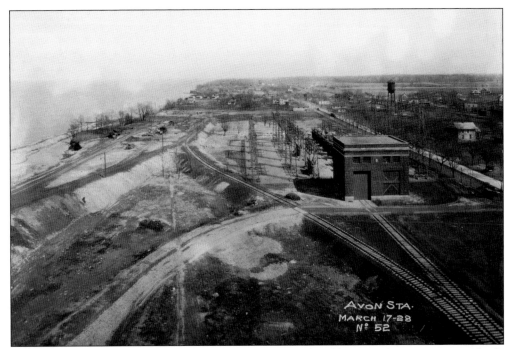

CEI, Looking East from the Stacks, March 1928. The old power plant is now completely gone (see the dug-up area near the lake), and a switchyard is now in the foreground. (Courtesy of GenOn, Inc.)

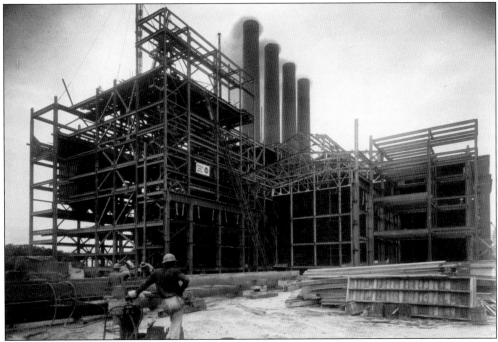

CEI Expansion, 1947. For those keeping track, 10 boilers, 5 turbines, and 4 stacks have been added to date. Here is the structure for 75-megawatt Units 6 and 7. Unit 7 is still in operation today. (Courtesy of GenOn, Inc.)

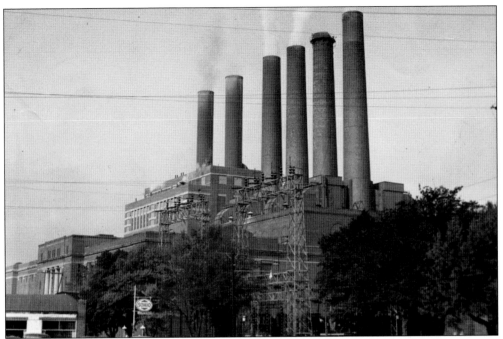

CEI Plant, 1950. With six stacks, the plant is shown, looking west, in 1950. Unit 8, a 232-megawatt experimental supercritical boiler, was completed in 1959 but decommissioned by the mid-1970s when it no longer met CEI's needs. (Photograph by Herman Seid; courtesy of CSU.)

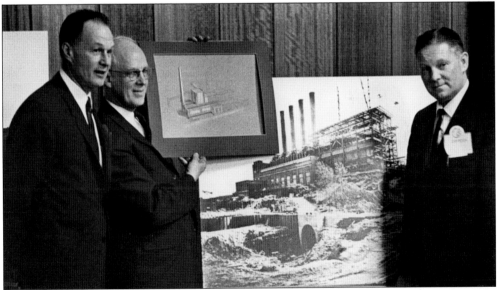

CEI Expansion Plans, 1966. Pictured reviewing the plant's history and the proposed expansion at the Aqua Marine Lodge are, from left to right, CEI vice president Lee Howley, CEI chairman Ralph Besse, and Avon Lake mayor John Picken. New equipment included the massive Unit 9, which has the tallest stack (600 feet) and the highest capacity (623 megawatts). Unit 9 still generates most of the plant's power today. Through the early 1970s, more pollution control equipment was demanded and built, including a 500-foot precipitator stack to clean up emissions from Units 6 and 7. (Courtesy of the City of Avon Lake.)

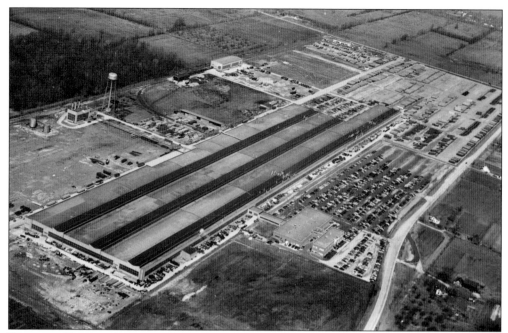

FRUEHAUF TRAILER COMPANY, 1953. Fruehauf Trailer Company, the largest truck-trailer factory in the world at the time, opened in the late 1940s, with assembly lines three-quarters of a mile in length turning out 6,000 trailers per month. Initial cost of the plant was $4.5 million. Fruehauf left by the late 1960s, but in 1974, the plant was updated, retooled, and expanded to reopen as Ford's Ohio assembly plant, the home of the Ford Econoline and, later, the Mercury Villager. (Courtesy of CSU.)

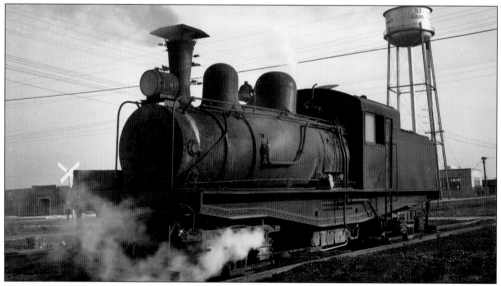

CEI COAL SHAY, 1948. B.F. Goodrich's research and production plant came to Avon Lake in 1946, and its water tower is visible in the background. This was the last segment of LSE track still in use. A new ramp and rail bridge was later constructed over Lake Road for the purpose of coal delivery. Since the late 1980s, coal is now delivered by conveyor belts. (Photograph by J. William Vigrass; courtesy of Dennis Lamont.)

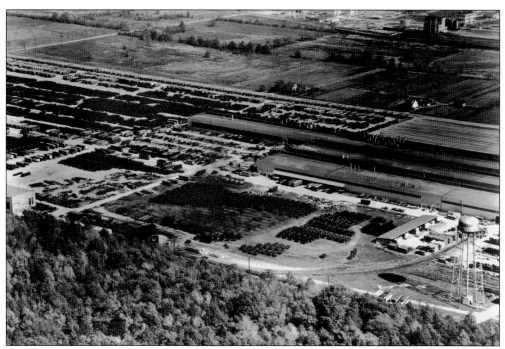

INDUSTRIAL VIEW OF AVON LAKE, 1953. This aerial photograph, looking northeast, shows the Fruehauf (later Ford) Plant in the foreground and the B.F. Goodrich Plant in the background. (Photograph by Robert Runyan; courtesy of the Bruce Young Collection at CSU.)

AVON LAKE INDUSTRY, 1978. A later view, looking north from Walker Road, shows more expansion at B.F. Goodrich. To concentrate on research and manufacturing of plastics and fertilizers, the plant became known as Geon, a spin-off from the Akron-based parent company. Following a merger with the M.A. Hanna Company in 2000, Geon became PolyOne, which now employs 3,600 people in 20 countries. (Photograph by Bill Nemez; courtesy of CSU.)

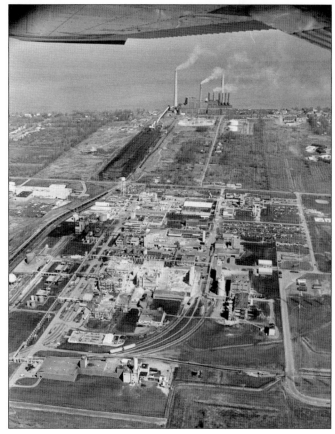

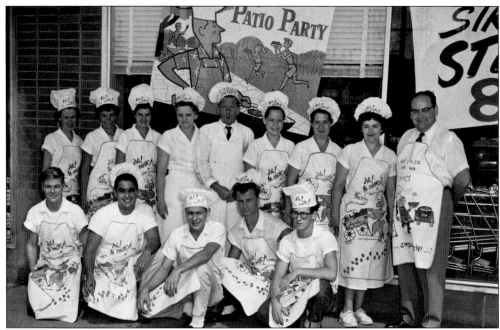

SPARKLE MARKET STAFF, 1955. Bob's Market, Lotts, and Sparkle Market had overlapping histories in the Saddle area. Here, Sparkle staff get ready for a Patio Party to promote Chow Mein products. From left to right are (first row) Bob Berry, Bud Faragher, Fritz Kistner, Jim Warren, and Joe Borer; (second row) unidentified, Nancy Fashing, two unidentified women, Chuck Jones, unidentified, Marie Hill, Julie Blaha, and manager Dan Scarpitti. (Courtesy of Josephine Scarpitti Hamilton.)

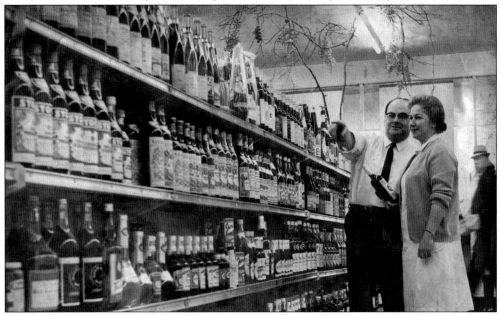

DAN'S DELI OPENING, 1960. Dan Scarpitti and his wife, Dale, wanted to open their own business and, in 1960, got to do so with the city's first eat-in deli in the ever-expanding Avon Lake Shopping Center. Here they are on opening day. Note the real grape vines on the ceiling. (Courtesy of Josephine Scarpitti Hamilton.)

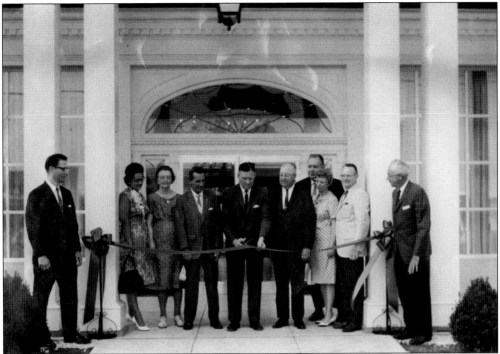

ELYRIA SAVINGS & TRUST OPENING, JULY 1966. Celebrating 65 years in business and 15 years in Avon Lake, company officials and staff of Elyria Savings & Trust (ES&T) cut the ribbon on a state-of-the-art $300,000 building at 33455 Lake Road. Bank vice president W.H. Gaston lived in Avon Lake. ES&T eventually became part of First Merit. This building is still intact but currently vacant. (Courtesy of Thomas Gaston.)

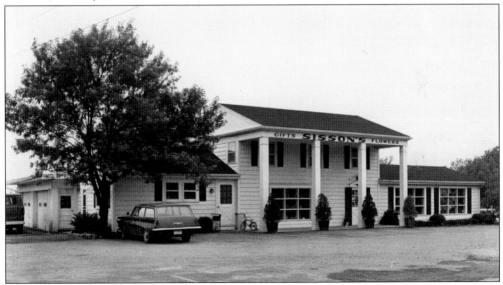

SISSON'S FLOWERS AND GIFTS, 1969. Located at 690 Center Road, this business was established by the Sisson family in the 1940s. Their store and greenhouses were behind the family homestead. Sisson's has since moved to new quarters south of Pin Oak Parkway. (Photograph by Fred Bottomer; courtesy of CSU.)

BURMEISTER FUNERAL HOME, MID-1970S. Fred and Dorothy Burmeister established Avon Lake's first funeral home in 1944 at the corner of Center Road and Electric Boulevard, which was not actually a street yet. They expanded an existing home built by F.J Roth, proprietor of Beach Park, in the 1920s and lived with their family upstairs. (Courtesy of William Burmeister.)

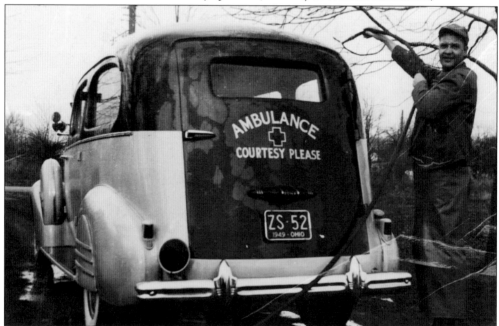

BURMEISTER AMBULANCE, C. 1950. Fred Burmeister washes an ambulance. It was once common for funeral homes to provide ambulance services, and Burmeister Funeral Home did so until the early 1970s. When Fred took ill, son William and daughter Gretchen began managing the business and opened another location in Avon in the early 1960s. Busch Funeral Homes bought out the Burmeister's funeral homes in 1986, but the family remains involved. (Courtesy of William Burmeister.)

Three

THE HEART OF
THE COMMUNITY

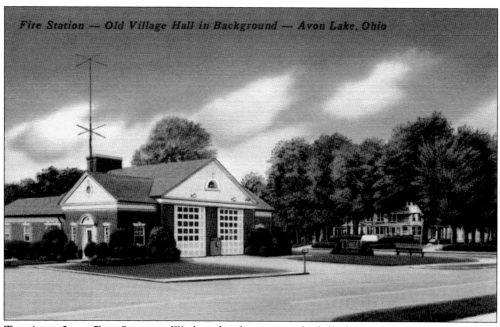

THE AVON LAKE FIRE STATION. Work and industry pays the bills, but a community's education, government, public safety, and cultural and social organizations make the good life possible. Avon Lake has always been a community of joiners, meaning residents have participated in many activities. Pictured is a postcard from the late 1940s showing Avon Lake's newly completed fire station. (Courtesy of Barbara Klingshirn.)

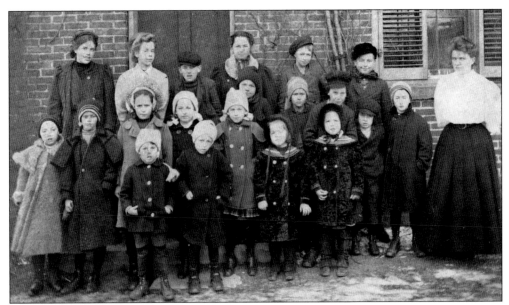

MOORE ROAD SCHOOL, C. 1914. Around 1850, Anson Titus built the first school, a log house on his property in northern Avon Township. It was moved to the northwest corner of Lake and Moore Roads in 1856. The school was then rebuilt, with bricks in 1874, as this school on the southeast corner of Lake and Moore Roads. When it was demolished in the 1980s, the bricks were used to pave paths around the restored Peter Miller House. (Courtesy of Gerry Paine.)

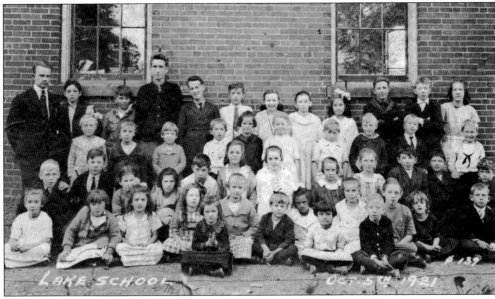

LAKE SCHOOL, 1921. Located at the corner of Lake and Jaycox Roads, this school was built in 1874. It was remodeled and incorporated into a residence by A.J. and Maude Laws in 1927, which, in turn, was demolished in 1998 to build another home. On the eastern end of town in 1887, John Walker's log school was replaced by a brick structure—the only two-room school in northern Avon Township, which became home to American Legion Post No. 211 in 1932. Another brick school was built in 1882 on Center Road north of Walker Road. It was used as a residence and demolished when Avon Lake Towne Center was built in the 1990s. (Courtesy of Paul Beck.)

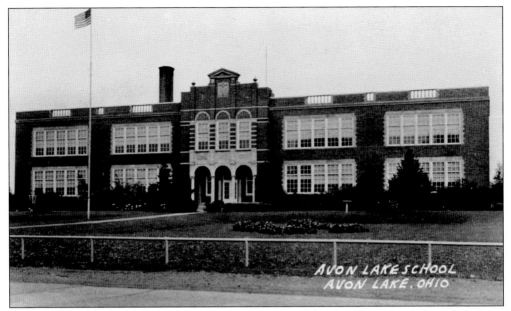

AVON LAKE SCHOOL, C. 1924. Following the separation of the one-room schools from their Avon counterparts and a growth in population, the new village decided to consolidate all students in this building on Center Road, south of the LSE. It was completed in 1923. Also, high school could now be completed in Avon Lake without going to Lorain or elsewhere; the first class of five students graduated in 1927. (Courtesy of Gerry Paine.)

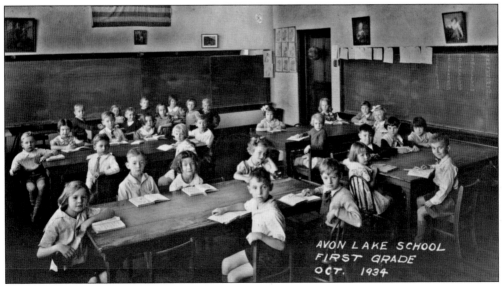

AVON LAKE SCHOOL, FIRST GRADE, 1934. At first, all grades had to fit into eight classrooms, which meant additions were needed in 1927 and 1935 as the school and village population grew. In 1934, the first through sixth grades were downstairs, and the seventh through twelfth grades were upstairs. (Courtesy of the girl with the curls directly in the center, Gerry Paine.)

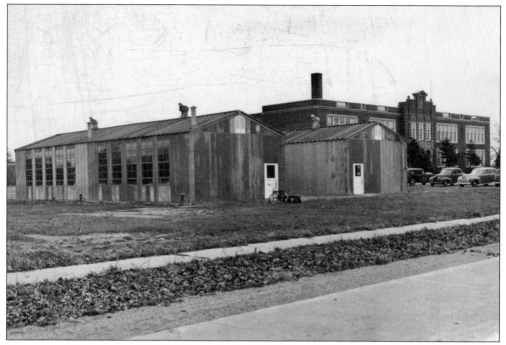

TEMPORARY CLASSROOMS, 1949. After two levies failed, these buildings were desperately needed to house the Avon Lake student population that had grown by 150 students in one year alone. Some grades even had to attend school in shifts. (Photograph by Fred Bottomer; courtesy of CSU.)

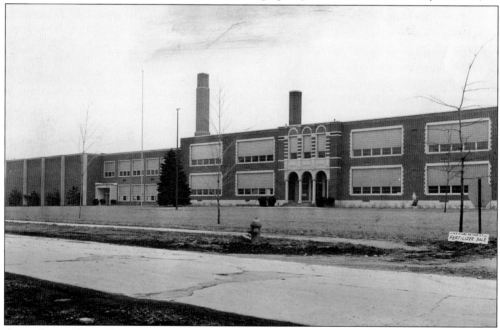

AVON LAKE HIGH SCHOOL, 1958. A levy finally passed to pay for needed expansion and improvements, including a new auditorium (on the left). As the city grew and spread out, it made sense to once again decentralize and plant elementary schools farther east and west. (Photograph by Frank Aleksandrowicz; courtesy of CSU.)

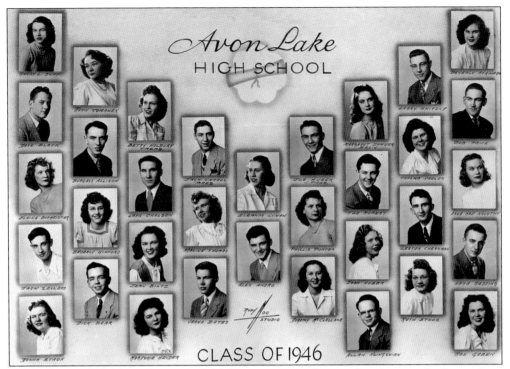

AVON LAKE HIGH SCHOOL CLASS OF 1946. This composite shows a class that remained very close; indeed, most of them stayed close to home and stayed in touch. At the first homecoming festival in 1982, this group vowed to meet every year. (Courtesy of Barbara Klingshirn.)

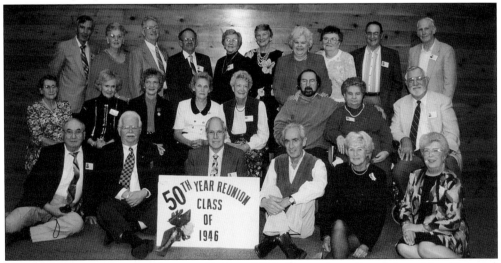

THE 50TH REUNION OF THE CLASS OF 1946 IN 1996. Pictured are, from left to right, (first row) Lars Carlson, Dick Bear, Vern Bates, Jack Zellers, Gerry (Duff) Paine, and Joan (Huber) Freeland; (second row) Eleanor (Lyman) Brusky, Adaline (Thomas) Bear, Ruth (Stoos) Scharmota, Anna Mae (Novoty) Nagel, Elaine (Burmeister) Kuttler, Jack Carrel, Phyllis (Porter) Heazlet, and Larry Snitzky; (third row) Herb Redding, Beverley (Gifford) Aufdenkampe, Dave Black, Allan Klingshirn, Dorothy (McClelland) Acheson, Jean (Biltz) Horning, Beverly (Horwedel) Jaroscak, Donna (Stroh) Brown, Joe "Coke" Huber, and Bob Price. (Courtesy of Barbara Klingshirn.)

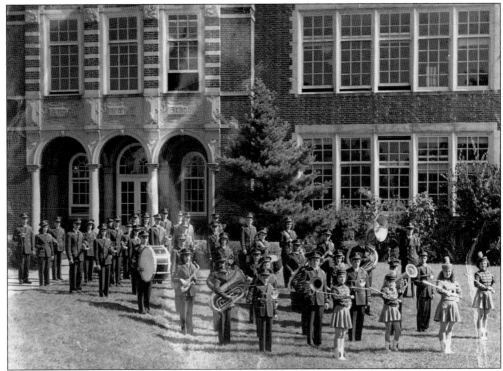

AVON LAKE MARCHING BAND, LATE 1940s. Band members pose for a picture in front of the school in their new uniforms. As the school continued to grow around it, this entrance portion remains and now houses the school board's offices. (Courtesy of Fritz Kuenzel.)

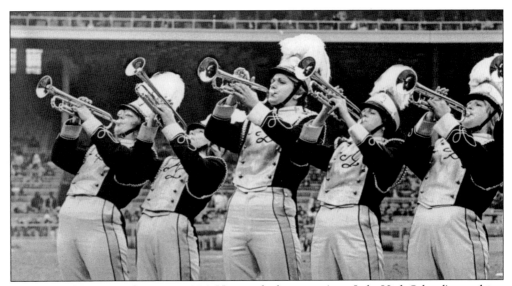

CLEVELAND MUNICIPAL STADIUM, 1976. Hitting the big time, Avon Lake High School's marching band is seen performing at a Cleveland Browns game in October 1976. (Photograph by Paul Tepley; courtesy of CSU.)

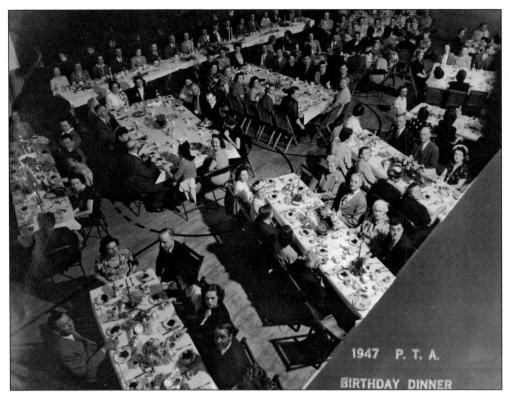

PTA Dinner at Avon Lake School, 1947. In 1923, the first Avon Lake PTA was formed with the new school. The organization took over much of what the Lake Shore Union did previously: helping schools and parents work together and improve the educational experience. (Courtesy of Fritz Kuenzel.)

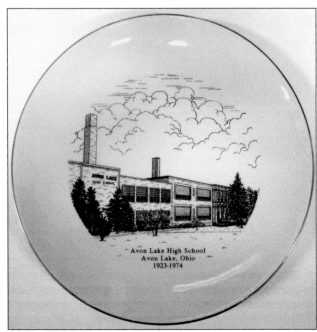

Avon Lake High School's 50th Anniversary. Here is a commemorative plate from 1974 for the school's 50th anniversary. The 1974–1975 yearbook, *Shore Log*, is full of historical photographs, trivia, and information about the construction of an addition made to the school that included the present-day library. Today, Avon Lake High School also has a performing arts center and a recently completed stadium. (Photograph by Kathy Diamond; courtesy of Doris Klement.)

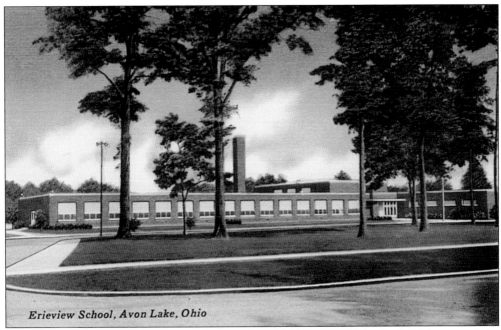

Erieview School, Avon Lake, Ohio

ERIEVIEW SCHOOL POSTCARD, C. **1954.** Located a few blocks east of the high school, between Lake Road and Electric Boulevard, Erieview was the first new school to be opened in 1951. Eastview, on Lear Road, was opened the following year. Other new elementary schools included Westview (opened 1957) and Redwood (opened 1962). (Courtesy of Harvey Miller.)

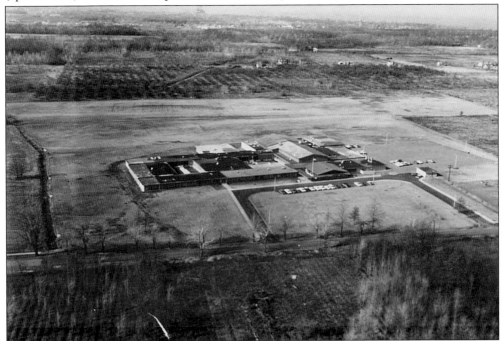

LEARWOOD SCHOOL, C. **1963.** Located just south of Eastview on Lear Road, Learwood became the citywide junior high school in 1960, giving the high school more room to grow. This aerial view is to the west, with Lear Road in the foreground. (Courtesy of the Avon Lake Engineering Department.)

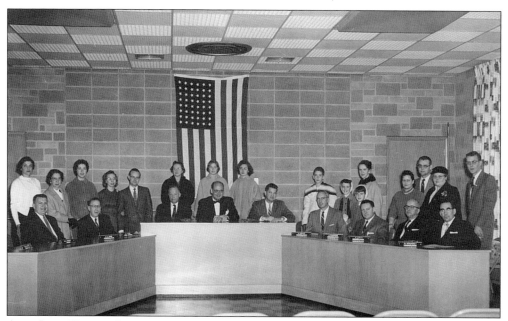

AVON LAKE VILLAGE COUNCIL, JANUARY 1958. Avon Lake enacted a charter in 1952 that allowed for the next step in becoming a city. Pictured are, from left to right, (seated) Robert Crawford, J.I. King, Alonzo Glenn (solicitor), Garry Moore (mayor), Ernest Palmer (clerk), Howard Hoxie, John Picken, Fred Lott, and Martin Sweeney. Their families stand behind them. This council would usher in the city era. (Courtesy of L. Francis Lott.)

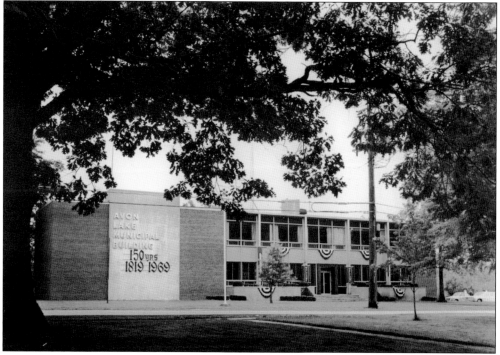

MUNICIPAL BUILDING AT SESQUICENTENNIAL, 1969. This building was expanded in 1973 to make room for the police department and then the municipal court. (Courtesy of Avon Lake Police Department.)

BUILDING THE NEW FIRE STATION, 1946. Avon Lake's fire department was organized in 1928 after a bucket brigade response to a neighborhood fire. Joseph Novotny, Carl Tomanek, and Robert Doughty, who became the first chief, were all volunteers. Initially based at the waterworks, their first fire truck barely fit in the garage, and a new pumper purchased in 1938 did not fit at all. So, they moved the trucks east, first to a garage at Tomanek's and then behind Kekic's gas station. This facility cost $35,000 to build, and Carl Haag became the first full-time fire chief. (Courtesy of John Early.)

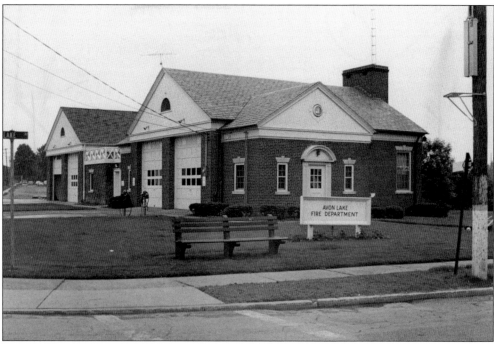

FIRE AND POLICE STATION, 1969. By this time, the building had been expanded and was being shared with Avon Lake Police. In 1978, the fire department moved to a larger, more centralized facility at Center and Walker Roads. The police moved to city hall until the new facility was expanded again in 2000. The old firehouse became a place for community theater performances and other activities. (Photograph by Fred Bottomer; courtesy of CSU.)

FIREMEN WITH TRUCK. Pictured here, showing off their new truck, are Willard Varner (left) and Harley Edwards. (Courtesy of Jean Waller.)

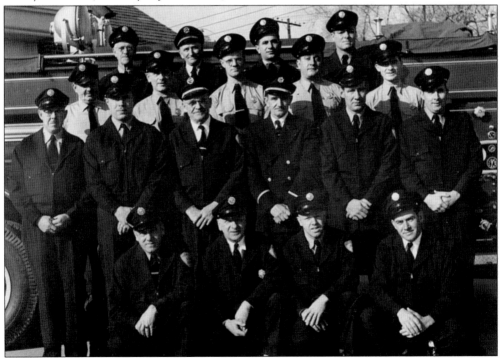

AVON LAKE FIRE DEPARTMENT, C. 1954. Pictured here are, from left to right, (first row) Bob Hentges, Steve Shannon, Willard Varner, and Bud Novotny; (second row) Harley Edwards, Junior Hill, Hank Kinsner, chief Carl Haag, and two unidentified men; (third row) all unidentified; (fourth row) Doc Collum, Joe Novotny, Pat Jerome, and George Baird. (Courtesy of Bud Haag.)

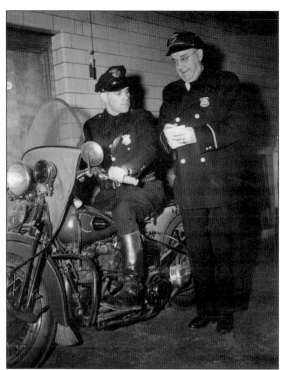

POLICE HEADQUARTERS, 1949.
Patrolman Leroy Linden (sitting on the motorcycle) reports to Avon Lake's first full-time police chief, Bill Arnold. Arnold was promoted from the part-time village marshal position to satisfy a state law in 1938. Before radios were available, a flashing light on the building was turned on to let passing police officers know to stop in for a message. Linden would later become chief. (Courtesy of Avon Lake Police Department.)

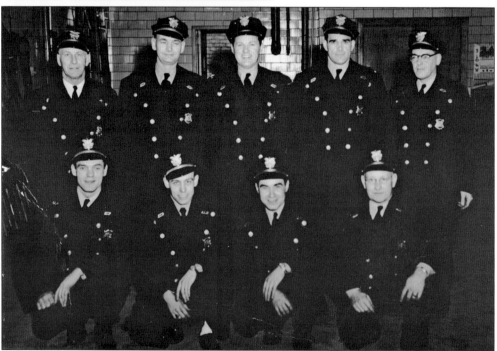

AVON LAKE POLICE DEPARTMENT, 1953. This image was taken from a 1954 calendar. Pictured are, from left to right, (first row) Roy Hansford, Jim Taylor, Ernie Leonard, and Ed Spaetzel; (second row) Duke Doutille, Dick Lutz, Terry Valek, Roy Linden, and Les Alger. (Courtesy of Avon Lake Police Department.)

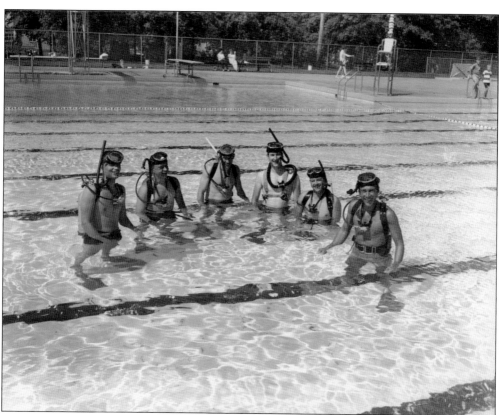

UNDERWATER RESCUE TRAINING, 1967. Having suffered tragic losses in the past, it made sense for Avon Lake and nearby communities to have an underwater recovery team. Here, police and city employees train in the municipal pool for emergencies on the lake. (Courtesy of Avon Lake Police Department.)

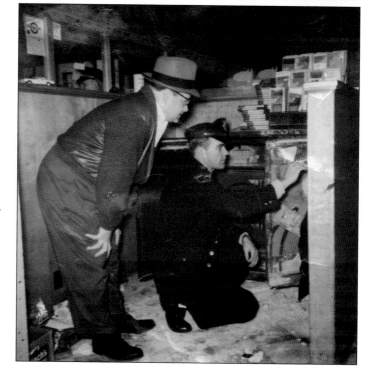

BREAK-IN, 1958. Manager Dan Scarpitti (left) and future police chief Roy Linden investigate a break-in at the Sparkle Market. Heavy equipment was used to smash the front window and the door of the safe next to it. (Courtesy of Josephine Hamilton Scarpitti.)

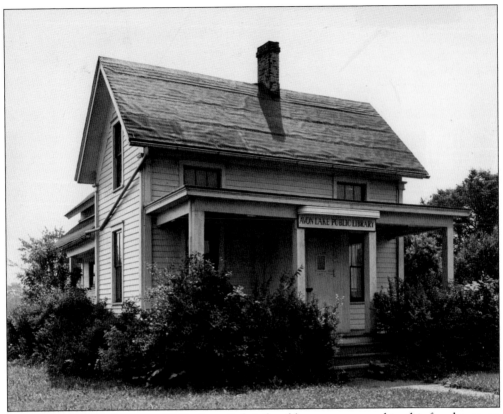

AVON LAKE PUBLIC LIBRARY, 1941. Avon Lake's first library was opened in this farmhouse on the east side of Center Road in 1931. Rented for $10 per month, it was next door to Avon Lake School. In the first year, circulation included almost 9,000 items. By 1955, use had grown, space had shrunk, and a new building was badly needed. A two-year bond issue provided enough money, and the new building at 32649 Electric Boulevard opened in 1958. (Photograph by Fred Bottomer; courtesy of CSU.)

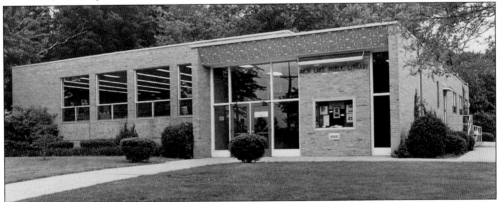

AVON LAKE PUBLIC LIBRARY, 1969. Avon Lakers loved their new library so much that it became crowded in a hurry. A 1983 addition to the back doubled space for collections and activities. In 1994, another addition and face-lift increased space to 55,000 square feet. The library now boasts 300,000 visitors and 640,000 items checked out per year, with high rankings in Ohio and nationally for exceptional facilities, staff, and service. (Photograph by Fred Bottomer; courtesy of CSU.)

GARDEN CLUB GIFT, c. 1955. The Avon-on-the-Lake Garden Club was organized in 1930 and has had a close relationship with the library ever since. Here, Florence Wentzel (left) and Marguerite Bricker present a check for $50 to librarian Merlin Wolcott to purchase titles on gardening for the collection. The group still donates gardening books, meets at the library, and has won regional and national awards for its work. (Courtesy of Alfreda Taylor.)

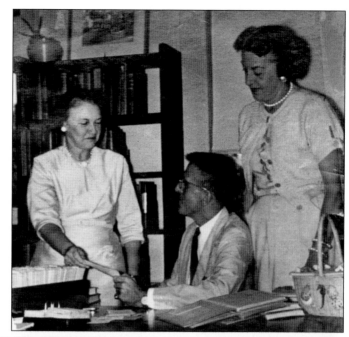

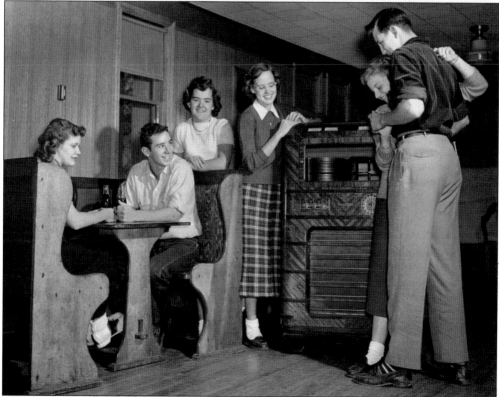

TEENAGERS AT VILLAGE HALL, 1949. This multipurpose room at the Village Hall was often used for activities for teenagers. Pictured are, from left to right, Carol Webber, Tim Flynn, Maureen O'Brien, Rita Eversole, Lois Lambert, and Jack Anderson. (Photograph by Fred Bottomer; courtesy of CSU.)

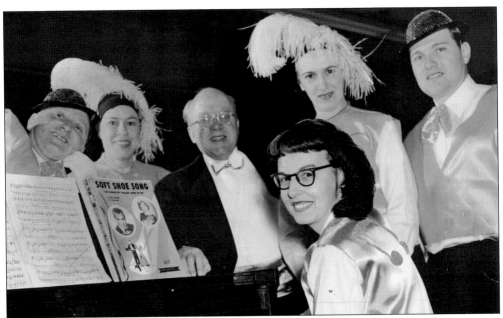

AVON LAKE PLAYERS, 1960. Formed in 1952, the players began a tradition of musical theater that continues today with Mighty Goliath Productions (MGP). MGP still puts on annual musicals that involve people from every part of the community. Seen rehearsing for an Eastview School fundraiser are Katy Frindt (seated) and (standing from left to right) Vincent LaForgia, Frances Emmerling, Walberg Brown, Helen Bollenbacher, and Richard Coffey. (Courtesy of CSU.)

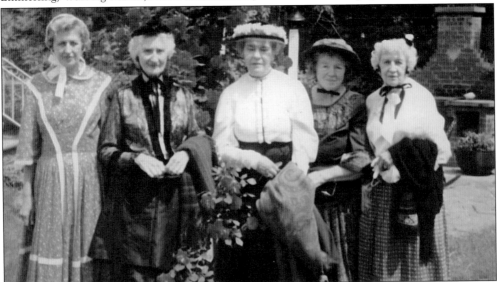

AVON LAKE HISTORICAL SOCIETY, 1969. In 1895, the Lake Shore Union Society was formed to support education and other worthy causes in the area. This became the Lake Shore Women's Club in 1952, which is still active—along with some of the groups it gave birth to. Some members helped to restore the Peter Miller House as a sesquicentennial project. The goal was to establish a museum there and keep an interest in history alive in the community. Thus, the Avon Lake Historical Society was born. Those pictured are, from left to right, Adelaide Green, Maizie Schultz, Olivia Hill, Ella Handy, and Dorothy Duff. (Courtesy of Nancy Abram.)

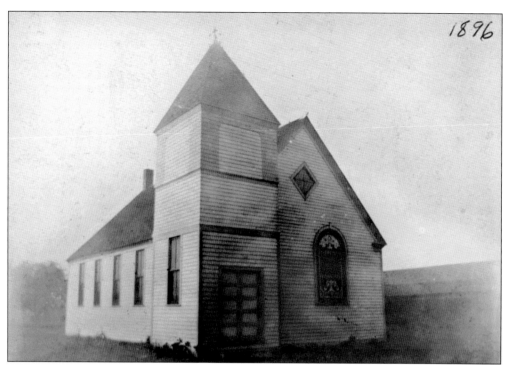

FIRST CHURCH BUILDING IN AVON LAKE, 1896. The Avon Lake United Methodist Episcopal Church was built at the corner of Lake Road and Beachdale Avenue on donated land. The members changed affiliation to Congregational in 1926. In 1929, the building was moved onto a foundation with a basement, and an addition was constructed in 1936. (Courtesy of Avon Lake United Church of Christ.)

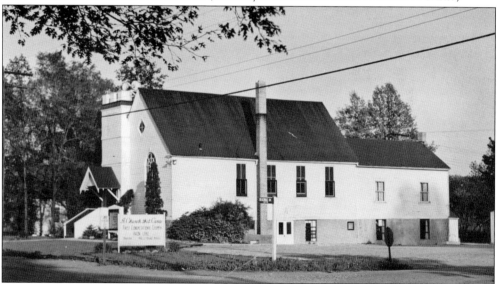

FIRST CONGREGATIONAL CHURCH, EARLY 1950S. Rev. Paul J. Folino, who took the church to its next location on Electric Boulevard in 1955, is listed on the sign as minister. During the late 1940s, Avon Lake's kindergarten classes were held here due to a lack of space in schools. The building was then sold to the Church of the Nazarene and, today, remains standing as a private home. (Courtesy of Avon Lake United Church of Christ.)

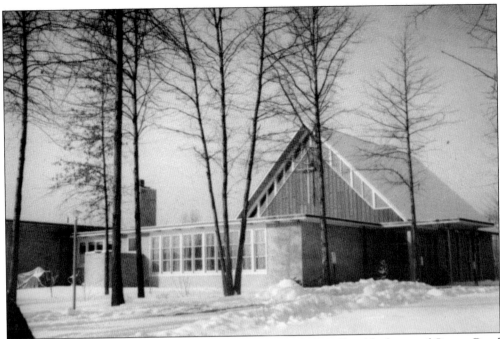

First Congregational Church of Avon Lake, late 1950s. One block east of Center Road on Electric Boulevard, this building was completed in 1955. The Congregational Church merged with the Evangelical and Reformed Church in 1967, and the denomination has since been called United Church of Christ (UCC). Major expansions and renovations took place on this site in 1977 and again in 2006. (Courtesy of Avon Lake United Church of Christ.)

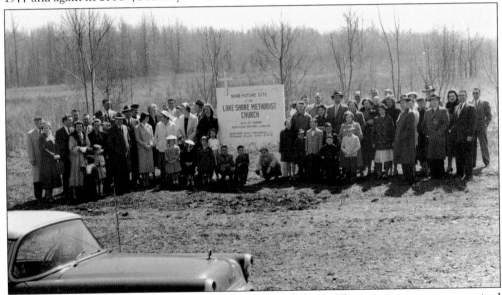

Future Site of Lake Shore Methodist Church, April 1960. This congregation was organized in 1956 and met at Eastview Elementary School for many years. In the former vineyards of Florence Miller (near the corner of Richland Drive and Electric Boulevard), Rev. Thomas Canton and parishioners gather in front of a sign where their first church will stand later that year. (Courtesy of John Runyon.)

DEDICATION OF LUTHERAN CHURCH, 1947. Pastor Vernon Grabel and Harold Krause bless the addition made to a house at 32747 Lake Road, which became Avon Lake Lutheran Church. A recent seminary graduate, Reverend Grabel and his growing family lived in the basement. By 1954, the congregation had grown to 300 members, and the Grabels left to lead a church in Baltimore. Sadly, Reverend Grabel passed away the following year at age 34, leaving behind his wife, Mary, and three young children. (Courtesy of Marilyn Pressnell.)

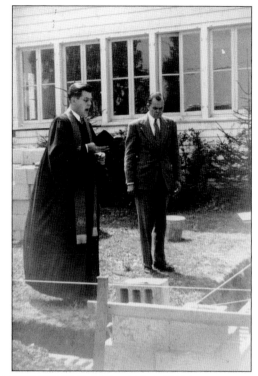

AVON LAKE LUTHERAN CHURCH, c. 1962. In 1964, the church became known as Christ Evangelical Lutheran Church, and a modern church campus was built on the site. (Courtesy of Marilyn Pressnell.)

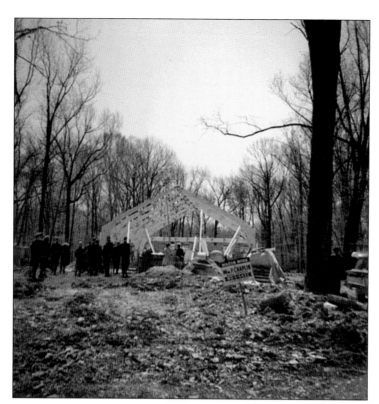

CALVARY CHURCH'S CONSTRUCTION, 1963. Calvary Baptist Church was formed in 1954 and met in members' homes. However, the group grew fast and soon began raising funds for land and a sanctuary on Electric Boulevard. For seven years, they conducted Sunday services in Erieview Elementary School's gymnasium across the street. (Courtesy of Calvary Baptist Church.)

CALVARY'S CORNERSTONE, APRIL 1963. Pictured here are general contractor William Chaplin (left) and pastor Robert Cessna. The church has since been expanded several times and a new building will be erected, as the congregation recently purchased property farther south in the city and is saving for a new construction program. (Courtesy of Calvary Baptist Church.)

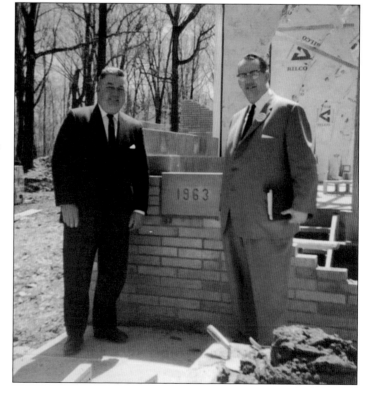

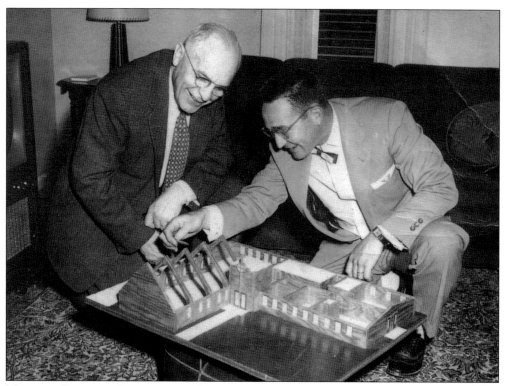

MODEL OF PROPOSED PRESBYTERIAN CHURCH, 1955. Avon Lake Presbyterian Church began as a mission in 1951, meeting in the Masonic Temple on Lear Road. Here, John Robertson (on the right) shows pastor George Dutton a model of what is to come. A master carpenter, Robertson was well known for his models of ships and lighthouses. (Photograph by Evelyn Fisher; courtesy of John Robertson.)

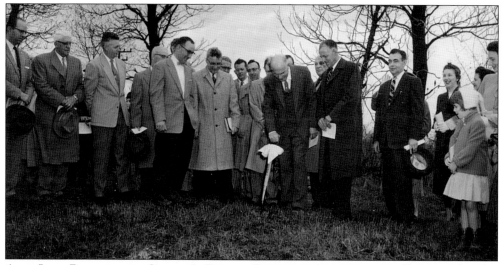

AVON LAKE PRESBYTERIAN CHURCH'S GROUND BREAKING. At center, pastor Dutton and, to his right, Mayor Lynus Rupert break ground for the church on Electric Boulevard in April 1956. It was completed the following year at a cost of $95,000. It was expanded in 1967 and renovated extensively in 1977. (Courtesy of Avon Lake Presbyterian Church.)

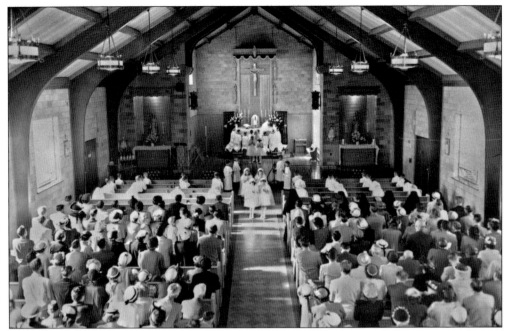

St. Joseph Catholic Church's Interior, 1952. Catholics in Avon Lake were members of other parishes and did not establish their own church until 1949. Fr. Carl Wernet, the founding priest, was with St. Joseph until 1966. Sunday services were held in the Avon Lake Theater until the church was completed in 1950. Here, First Communion is being celebrated. (Courtesy of Nancy Abram.)

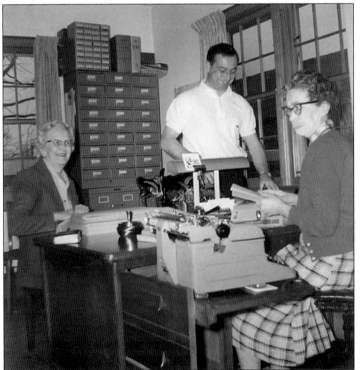

St. Joseph's Old Rectory Office, 1959. Pictured are, from left to right, assistant secretary Marguerite Jones; the first assistant priest, Father Zarling; and sister of and housekeeper to Father Wernet, Ruth "Petie" Wernet. (Courtesy of Barbara Klingshirn.)

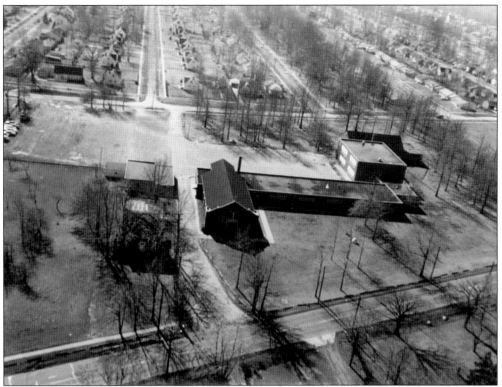

AERIAL VIEW OF ST. JOSEPH, C. 1962. This aerial view is looking south over Lake Road. The church's campus has grown steadily over time, and the two-story addition to the school, seen on the right side, confirms it. In 1999, a brand-new sanctuary was built to the west. (Courtesy of Avon Lake Engineering Department.)

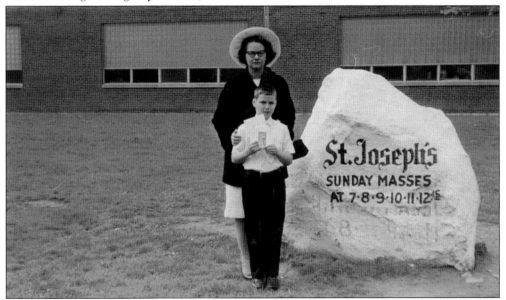

ST. JOSEPH CHURCH, 1968. Lois Ouelette and her son Paul are seen together at his First Communion. (Courtesy of Mark Ouelette.)

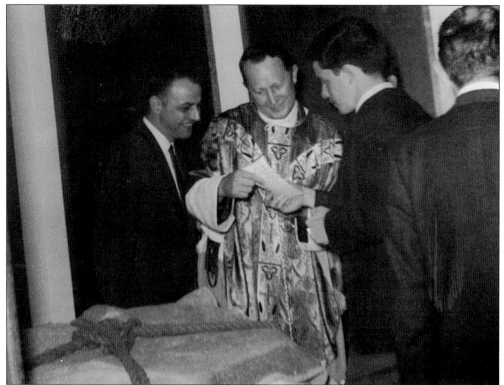

CORNERSTONE OF HOLY SPIRIT CATHOLIC CHURCH. As the local Catholic population and St. Joseph grew, it was time to form another church. Fr. James Mosovsky is pictured here in September 1967, laying the Holy Spirit's cornerstone, which is also the base of church's baptismal font. (Courtesy of Holy Spirit Catholic Church.)

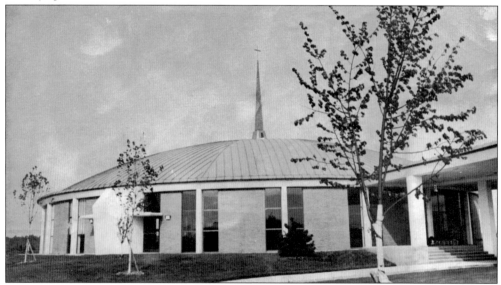

HOLY SPIRIT'S EXTERIOR, 1968. Until their unique round sanctuary was completed, members of the church held services first at Mosovksy's rectory on Krebs Road and then at Learwood School. The church was dedicated by Bishop Issenman in June 1968. (Courtesy of Holy Spirit Catholic Church.)

Four

LIFE BY THE LAKE

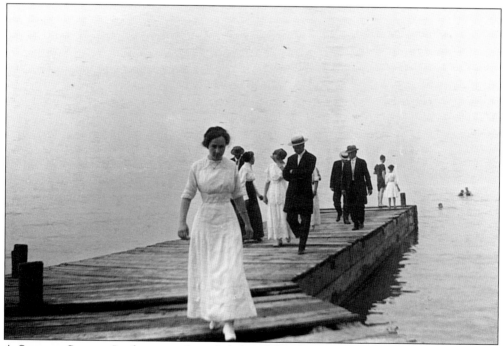

A SUMMER STROLL. Look now at Avon Lake's rich history of beaches, homes of early settlers, recreational facilities, and activities that took place here—many of which are still in existence. In this photograph, Florence Beard is leading family members down a boardwalk around 1910. Without Lake Erie, this area would be like any old place. (Courtesy of Debra Beard.)

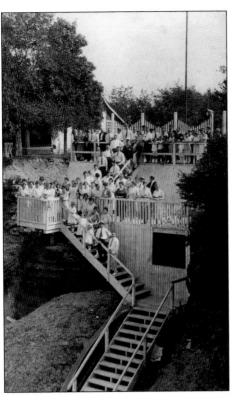

NORTH POINT, C. 1920. Revelers celebrate the opening of these stairs to the beach just north of "the 45." North Point is also known as Eagle's Nest. (Courtesy of Glenda Nelson.)

PICNICKERS AT BEACH PARK, C. 1910. On a typical weekend around this time, 20,000 visitors per day would take the trolley to Beach Park and walk across Lake Road with baskets in tow. (Courtesy of Debra Beard.)

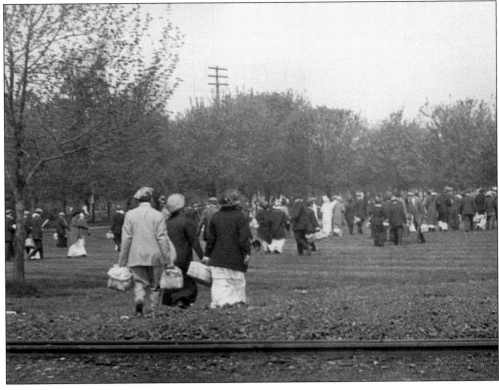

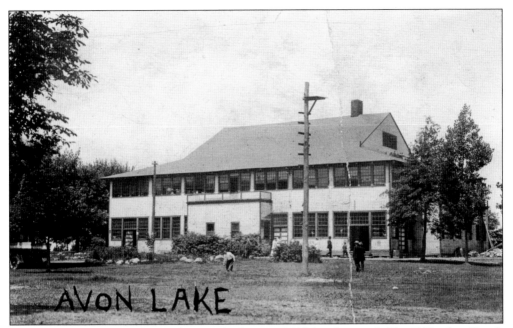

BEACH PARK PAVILION. The pavilion was built around 1904 and expanded by 1908, when Beach Park came under the management of F.J. Roth. A poster from the reopening states the following: "The better class of patronage is solicited, and we reserve the right to eject any objectionable persons from the premises." (Courtesy of Thomas Patton.)

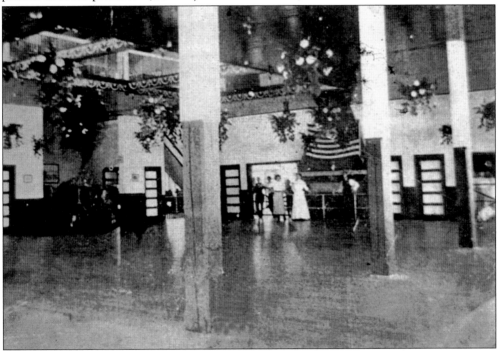

THE INTERIOR OF BEACH PARK PAVILION. A popular place for dancing, dining, meeting, and playing pool, not a trace remains of this building, which was demolished around 1924. (Courtesy of Thomas Patton.)

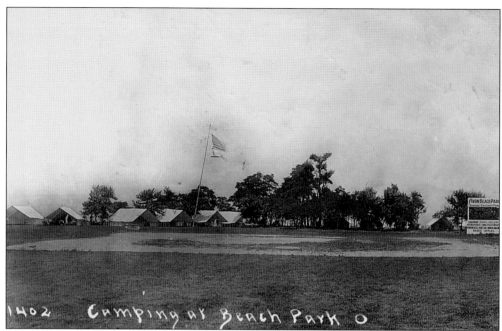

CAMPING AT BEACH PARK, C. 1910. Whether staying overnight in these tents and cottages or just visiting here for the day, supplies were sold to all at this campsite. (Courtesy of Thomas Patton.)

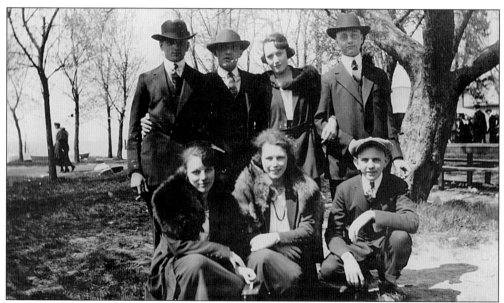

AVON BEACH PICNICKERS, MAY 16, 1920. Looking north beyond the picnickers, Lake Erie is seen in the background. (Courtesy of Richard Walz.)

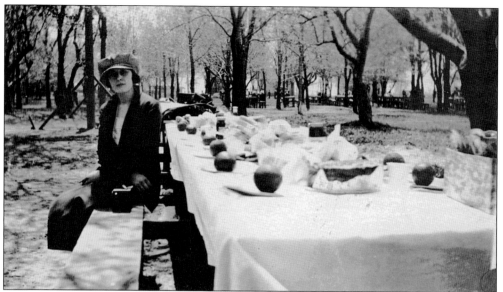

PICNIC TABLE AT AVON BEACH, 1920. A table is prepared, with many others in the background. (Courtesy of Richard Walz.)

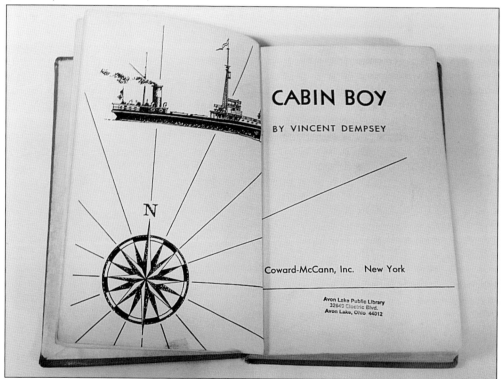

VINCENT DEMPSEY'S CABIN BOY. In 1956, news and television writer Vincent Dempsey published the book *Cabin Boy*, which is a novel inspired by his summers spent in Avon Lake in the 1890s. It is clear many local characters and places—including retired captain Orlo Moore, Mills Store, and Lake Shore Cemetery—appeared under slightly different names in the book. (Photograph by Kathy Diamond; courtesy of the Avon Lake Public Library.)

THE PETER MILLER HOUSE, 1969. Located at 33740 Lake Road in Miller Road Park, this house was purchased in 1964 by the city, with the long view of establishing a museum. It was still occupied by the Huber family until 1968. There was just enough time to get things ready for the sesquicentennial. (Photograph by Fred Bottomer; courtesy of CSU.)

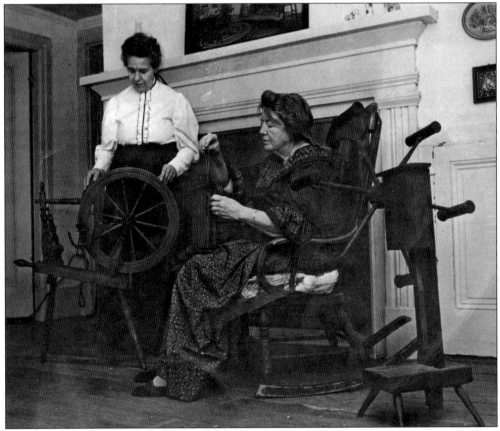

SPINNING DEMONSTRATION, C. 1970. Avon Lake Historical Society founding members Olivia Hill (left) and Ella Handy demonstrate spinning and other pioneer activities at the Peter Miller House Museum. (Courtesy of Avon Lake Historical Society.)

THE PETER MILLER HOUSE, C. 1985. In 1975, this building was severely damaged by burst pipes, and it was abandoned for 10 years. However, there was enough interest to keep it from being demolished as an eyesore or for expanding Miller Road Park. It was placed on the National Register of Historic Places in 1978. (Courtesy of Gerry Paine.)

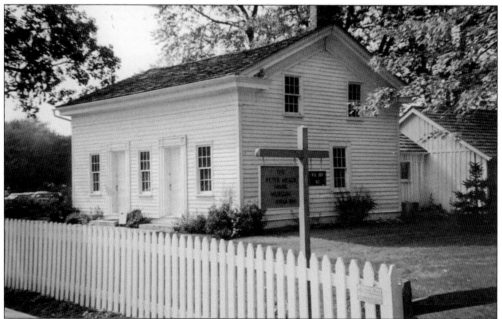

THE PETER MILLER HOUSE, POST-1989. A new organization was formed to preserve the home. Furniture was put in storage. The house was rebuilt with much support from local contractors and volunteers. It was temporarily moved from its foundation so that a new foundation could be constructed. Today, the museum is open regularly for public tours and programs. (Courtesy of Gerry Paine.)

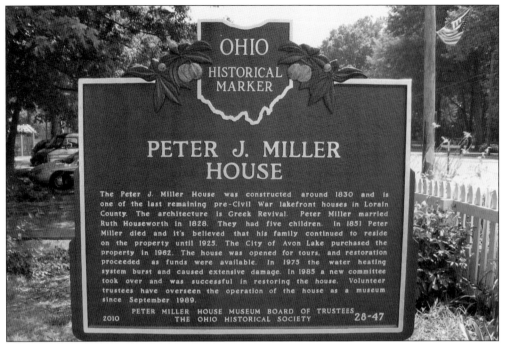

OHIO HISTORICAL MARKER. On July 4, 2010, this shiny new marker from the Ohio Historical Society was unveiled—the first one in Avon Lake. The reverse side describes the history of Adam Miller's family, including an incident where a young Peter Miller was chased up a tree by a bear, later recounted for millions of students in William McGuffey's *Second Reader* published in 1844. (Photograph by Gerry Paine.)

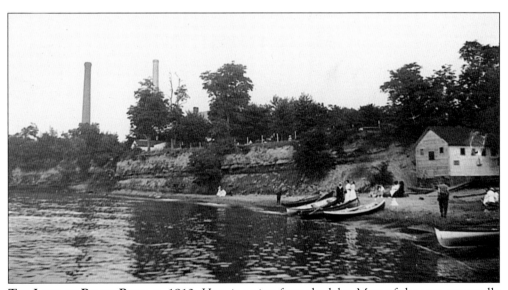

THE LAKE AT BEACH PARK, C. 1910. Here is a view from the lake. Most of the area eventually became part of the CEI plant, however, the far right side is now part of Miller Road Park. (Courtesy of Debra Beard.)

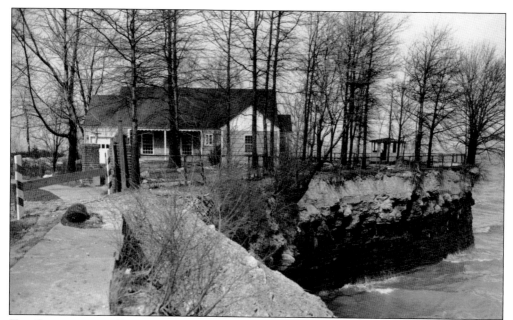

THE SHORELINE AT COVELAND DRIVE, 1949. Lake storms take their toll on land and in the water, and erosion was a constant battle for early settlers, as it is today. In June 1868, one of Lake Erie's greatest tragedies took place near here: the passenger steamer *Morning Star* collided with the merchant sailing ship *Courtland*, and 45 lives were lost. (Photograph by Glenn Zahn; courtesy of CSU.)

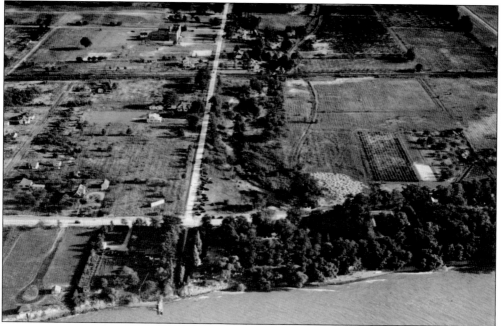

AERIAL VIEW OF STOP 56 AREA, 1930. This image is looking south down Center Road from the lake. Just north of the LSE, notice Avon Lake School has a recent addition. Just south of the school by the tracks, there is the house that became Burmeister's Funeral Home, and just north of the school, one can almost see the future Avon Lake Public Library. (Courtesy of CSU.)

AVON LAKE PARK, 1930. This image from the corner of Lake and Center Roads was taken the same day as the previous photograph. Because of the trees, one cannot even see Park Hall or Lake Shore Cemetery. (Courtesy of CSU.)

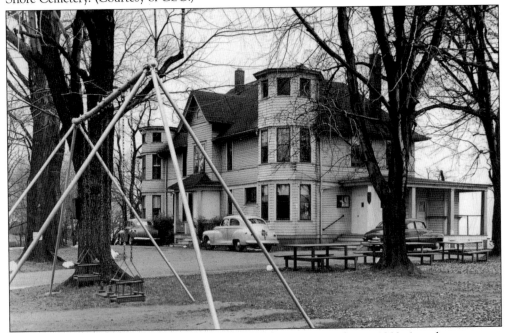

PARK HALL/VILLAGE HALL, 1949. Park Hall was built by Thomas Folger in 1902. A civil war veteran, Folger inherited lakeshore property from his father, Henry, in 1878. He raised grapes and became the head of a syndicate for local growers. Though possibly constructed as an inn, his daughters and their families mainly used the house as a summer residence. Folger spent most of his time and energy in Elyria, where he served a term as mayor. While campaigning for a second term, he died at this house in 1909. The city purchased it in 1926, providing residents a park with beach access and a seat for village government. (Photograph by Fred Bottomer; courtesy of CSU.)

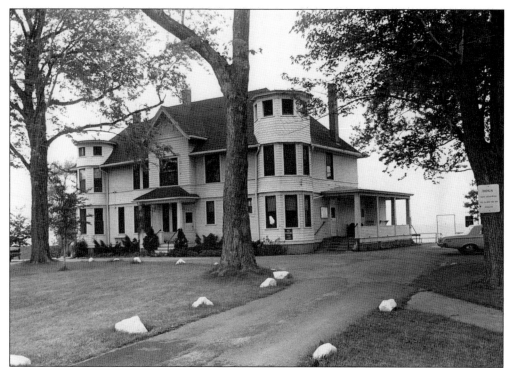

OLD VILLAGE HALL, 1969. Notice in this image that very little had changed in the house's appearance since the 1940s. Most government functions moved out by 1956, but this was still a hub for community activities, such as theater rehearsals. Avon Lake's municipal court was based here from 1958 to 1973, which was when it moved into an expanded city hall. Employed by the city, caretakers and their families occupied an apartment here until 2002. (Courtesy of CSU.)

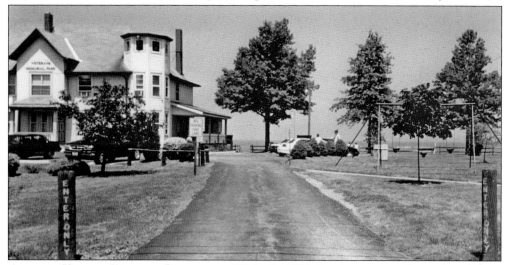

ASSEMBLY HALL AT VETERANS PARK, EARLY 1990S. By 2002, the city was considering demolishing the building because of multiple structural problems, but this did not sit well with many community members. As a result, the Avon Lake Landmark Preservation Society took on the job of preserving and restoring the building, which is a work in progress. It is once again known as the Thomas Folger Home. (Courtesy of Avon Lake Parks and Recreation.)

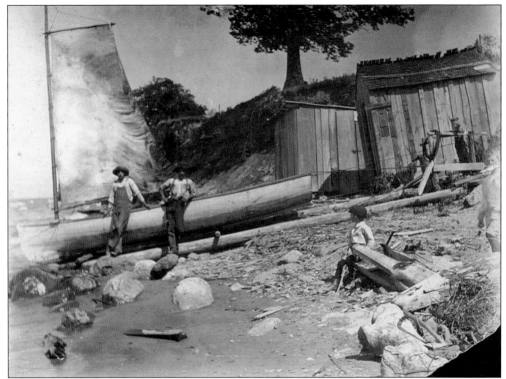

Duff Beach, 1898. Young Curtis Duff (sitting on a log) is shown with fishermen and a sailboat on the shore. Long poles cradled the boat, which was winched out of the lake using grape posts as rollers. (Courtesy of Gerry Paine.)

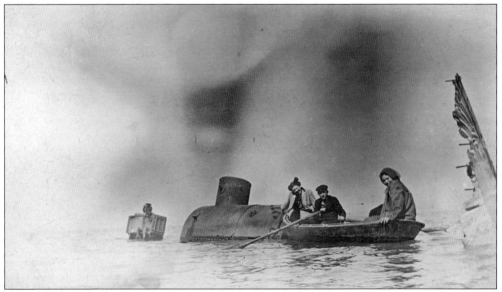

Wreck of Tugboat *Penelope*, 1909. From left to right, Ruth Mitchell, Curtis Duff, and Dorothy Mitchell inspect the wreck of the *Penelope* from Duff's rowboat. The propeller from another tugboat, the *Alva B.*, that sunk near Miller Road Park in 1917 was raised and put on permanent display in the park in 1989. (Courtesy of Gerry Paine.)

EDDY'S BOATHOUSE, JUNE 1940. Located about 100 yards east of the CEI property fence, this boat rental operation was the site of a mystery one June night when three unknown men rented a boat. Two of the men were apparently trapped behind the fence, and the third returned the boat damaged. After an exhaustive search, village marshal Arnold determined they disappeared to avoid paying. (Photograph by John Nash; courtesy of CSU.)

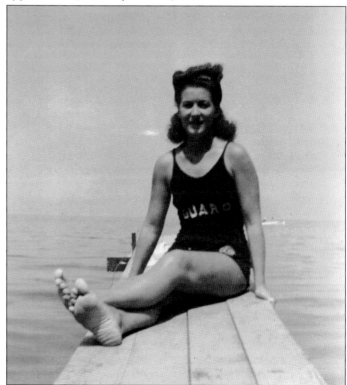

ELLEN TRIVANOVICH, C. 1950. An avid athlete and coach, "Miss Ellen" grew up on Avondale Avenue and attended Avon Lake School. She became a full-time lifeguard for the village in 1951, watching over the beach crowds at Avon Lake Park. During the next four decades, she taught thousands of children to swim. (Courtesy of Avon Lake Parks and Recreation.)

MUNICIPAL POOL'S OPENING, JULY 8, 1962. Mayor John Picken (far left), recreation director Howard Clary, and many children are seen waiting in line for the opening of the pool. The total cost was $129,440, which was paid for by a recreation levy passed in November 1961. (Courtesy of Avon Lake Parks and Recreation.)

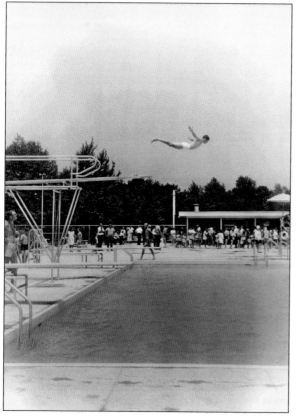

FIRST DIVE, JULY 8, 1962. The pool made a profit in its first season, as 75,000 swimmers were admitted. Season passes were $10 for individuals and $35 for families. (Courtesy of Avon Lake Parks and Recreation.)

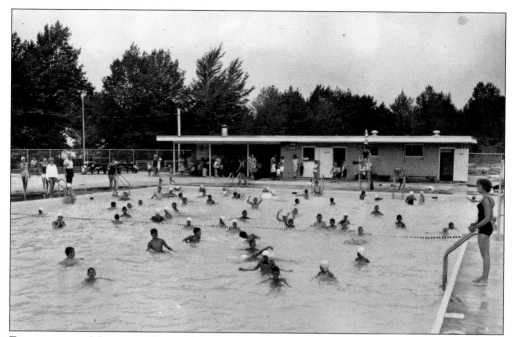

ENJOYING THE MUNICIPAL POOL, AUGUST 1962. On the occasion of her retirement in 1992, the pool was renamed in honor of Ellen Trivanovich. In July 2009, the old pool was demolished and replaced with the $4 million Ellen Trivanovich Aquatic Center, which opened a year later. (Photograph by Byron Filkins; courtesy of CSU.)

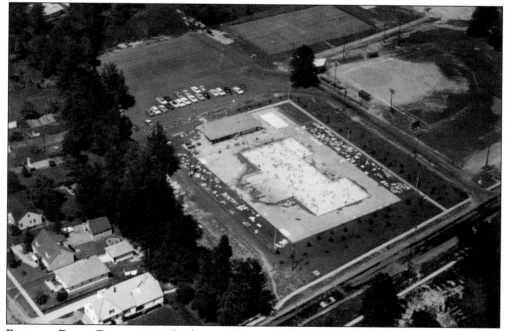

POOL AND BLESER PARK, C. 1963. Looking northeast, with Electric Boulevard and Brookfield Road in the lower left, there are a lot of people in the pool, but hardly any cars are parked in the lot. This was because it was an easy walk or bike ride for most residents, especially the younger ones. (Courtesy of Avon Lake Engineering Department.)

BLESER PARK, C. 1992. Part of the lands acquired by the village along with the Folger property included this area, which was designated for recreation in 1938. It was named in honor of Walter Bleser, who was instrumental in bringing Little League baseball to Avon Lake. Bleser was involved in building dugouts when he passed away in 1954. (Courtesy of Avon Lake Parks and Recreation.)

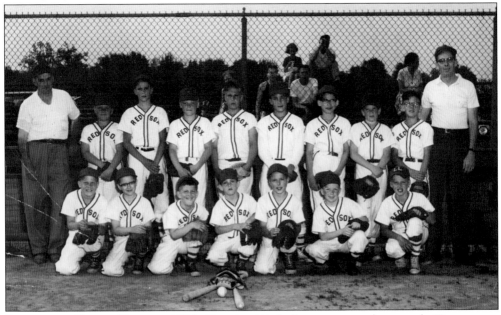

BASEBALL IN BLESER PARK, C. 1954. Here is a Little League team photograph. Teams were sponsored by local businesses. (Courtesy of Nancy Abram.)

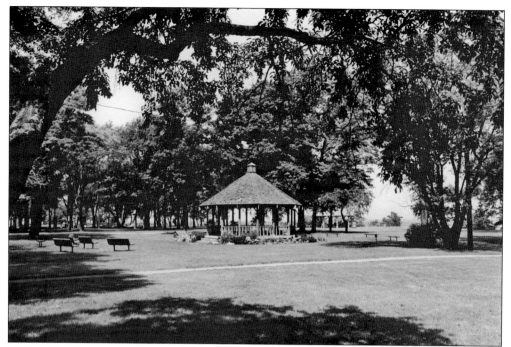

MILLER ROAD PARK, C. 1992. Looking northwest toward the lake, the gazebo is seen in the foreground. The flora and many trees were planted and are maintained by the Avon-on-the-Lake Garden Club. (Courtesy of City of Avon Lake.)

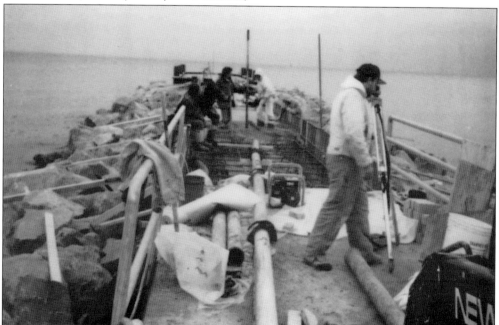

MILLER ROAD PARK PIER, 1997. Workers are seen completing a pier for recreation and fishing; they also improved the public boat launch and parking, creating more beach to be enjoyed. As previous pictures make obvious, the park requires ongoing measures to prevent erosion. (Courtesy of the City of Avon Lake.)

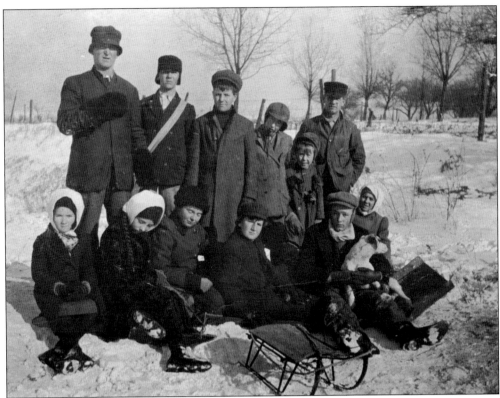

SLEDDING PARTY, C. 1900. Neighboring families get together on the Lake Erie bluffs. Those pictured from left to right in the first row are Ruth Mitchell; Florence, Hattie, and Glenn Beard; Curtis Duff (and dog); and Dorothy Mitchell. Only three boys in the second row are identified. They are Charles Beard (left), Maurice Mitchell (second from left), and Leonard Mitchell (far right). (Courtesy of Debra Beard.)

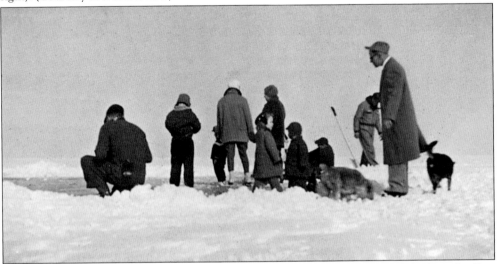

LAKE ERIE FROZEN OVER, FEBRUARY 1961. Many years later at the same place, lakeshore dwellers gather on the ice for fishing and skating during a particularly cold winter. Ice was smooth and six to eight inches thick. (Courtesy of Barbara Klingshirn.)

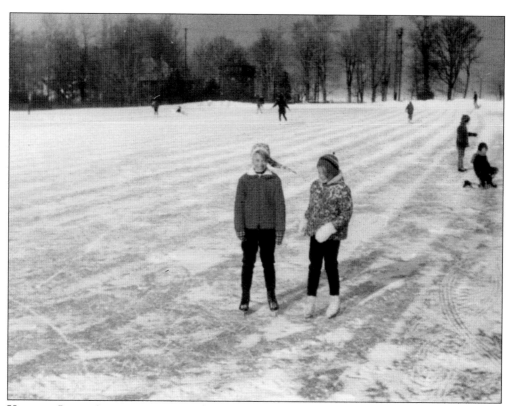

KAT AND JANET AMOLSCH, 1967. Looking north from behind the firehouse, sisters Kat (left) and Janet Amolsch ice skate in Bleser Park. As their mother remembers, the nearby fire department purposely flooded the field, a practice that began in the 1940s. (Courtesy of Doris Amolsch.)

NATURE TRAIL, 1957. Leonard Jarzen is seen near the entrance to a trail blazed by his brothers David and Robert in the vast undeveloped woods behind their 210 Fay Avenue home. Experiences here sparked David's interest in nature, and a science project in ecology led to a career in natural history. These woods, thanks to the efforts of a determined committee of local residents called Save The Woods, became the Kopf Family Reservation in 2008. It is jointly managed by Avon Lake and Lorain County Metroparks. (Courtesy of David and Susan Jarzen.)

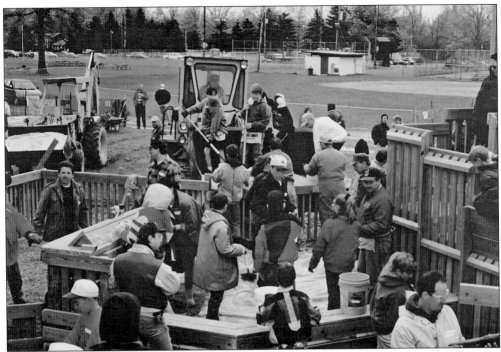

AVON LAKE PLAY SPACE, MAY 1994. This creative playground was built entirely with donated labor and materials, including $75,000 in sponsorships. It took years to get it started, but final assembly was a snap. During a two-week period, over 1,500 volunteers (up to 600 per day) worked to assemble the structure in Bleser Park. (Both, courtesy of the City of Avon Lake.)

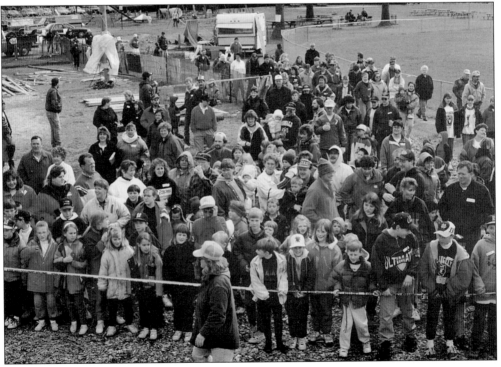

Five

REMEMBER WHEN

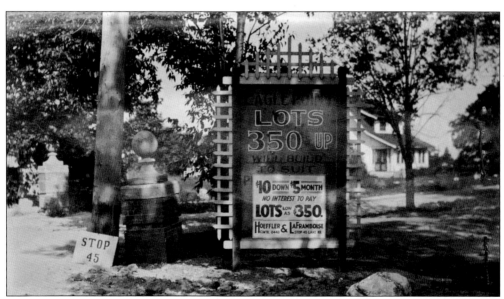

LAND FOR SALE NEAR STOP 45. What follows is a miscellany of what old-timers fondly recall when newcomers often ask: What was the Lake Shore Electric? The Saddle Inn? The Aqua Marine Lodge? What was life like back . . . when? What is left today? "Non-conforming signs," according to the 1935 scrapbook prepared for the village that this image was taken from, list land for sale near Stop 45. A parade of faded real estate signs and abandoned sales offices winds along Lake Road. (Courtesy of Barney Klement.)

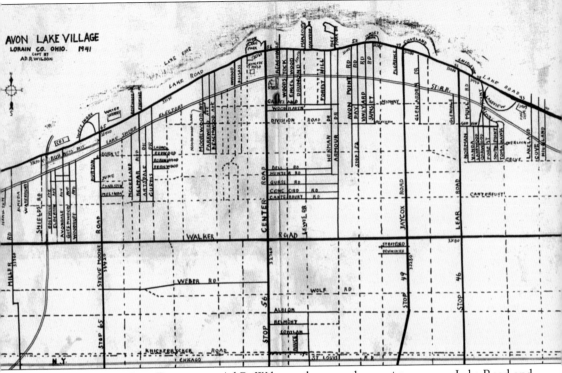

MAP FROM 1941 CITY DIRECTORY. Ad R. Wilson, who owned a tourist camp on Lake Road and real estate and construction interests, drew this map. He published it in a city directory he compiled in 1941. East to west street numbering (as well as stop numbers maintained for bus service) should help anyone orient one's self within this book. Many streets on this map were never completed and are still "paper streets," another leftover of the boom. (Courtesy of Gerry Paine.)

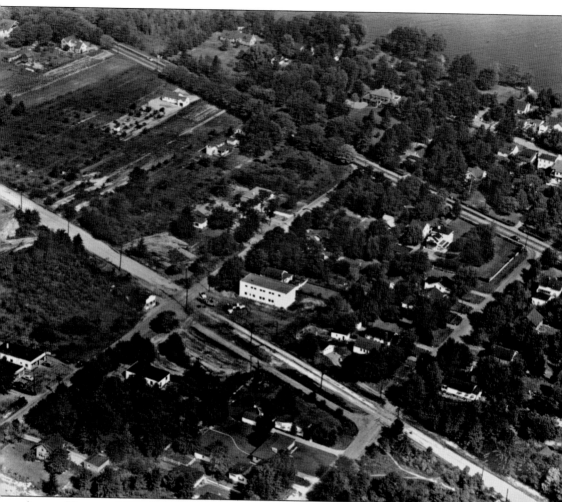

AERIAL VIEW, C. 1952. From left to right, intersections of Lear Road, Electric Boulevard (still partially finished), and Lake Road are in the foreground. Prominent in the center is the Masonic Temple (Lodge No. 725) finished in 1951. (Courtesy of Sharon Triska.)

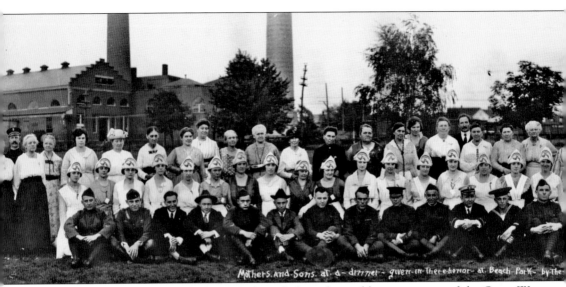

Mothers and Sons at a dinner given in there honor at Beach Park by the

AT BEACH PARK, SEPTEMBER 6, 1919. Avon Lake welcomed home veterans of the Great War, or World War I, in grand style. A total of 39 veterans, their mothers, and their wives enjoyed a dinner and dance with live music. Each veteran received a gift of $25, courtesy of the Our Boys Victory Fund, a project of the Lake Shore Union Society. Jane Cuyler Curtis's remarks on the theme "The Ideals of Service in Community Welfare" concluded with the following: "The ladies feel that perhaps all this cooperation and generosity will in a way become its own reward, in having developed a community feeling that will presently undertake something for

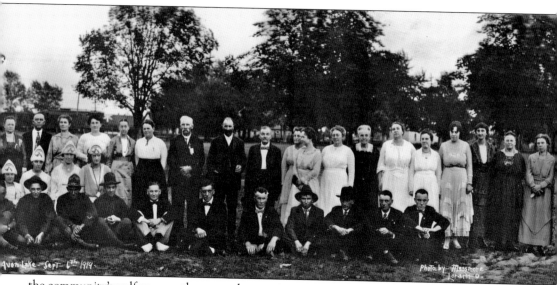

Avon Lake – Sept 6th 1919

Photo by – Messmore

the community's welfare, now that peace has come once more to our country." Pictured are, from left to right, (first row) unidentified, Edward Wagner, Fred Bergald, Curtis Duff, Edward Brodie, Robert Sherman, Clyde Robinson, Vern Jaycox, Fred Roth, Wilbur Roth, Maurice Mitchell, Hans Birk, Carl Beck, Henry Beck, Melcher Urig, Harry Weber, unidentified, Leo Heider, Jack Hinz, unidentified, Edward Pitts, unidentified, Earl Schall, Cecil Titus, and Harold Moore. (Courtesy of Avon Lake Public Library.)

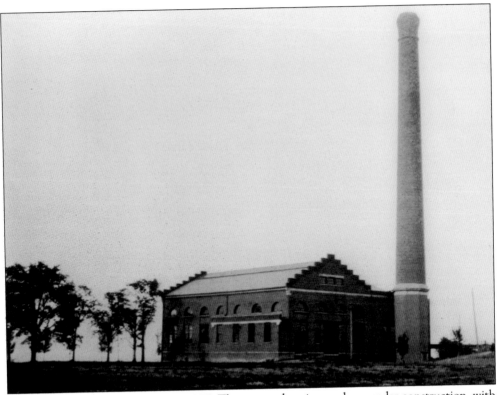

LSE's Beach Park Powerhouse, 1897. The power plant is seen here under construction, with only one stack completed. Cottagers and some nearby rural residents enjoyed electric power, while neighbors were still lighting with gas. (Courtesy of Thomas Patton.)

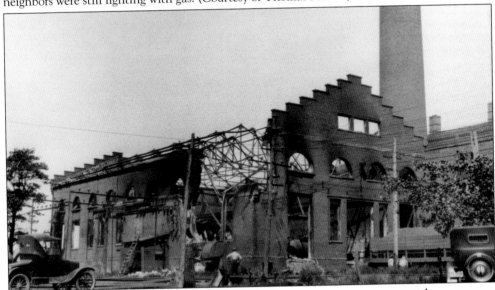

Powerhouse after Fire, August 1925. According to a contemporary news article, a generator explosion kindled oil stored in the basement and set the largely wooden roof on fire, cutting power up and down the coast. Water was not available quickly enough to put it out, and the building was had to be written off. (Courtesy of Thomas Patton.)

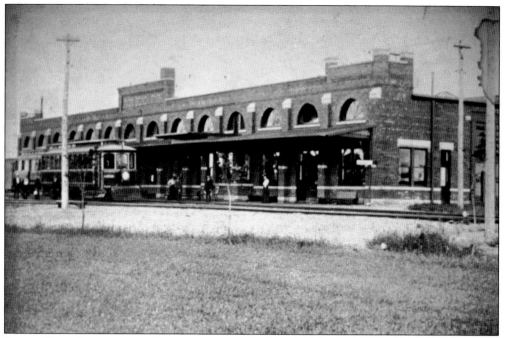

BEACH PARK STATION AND CARBARN, 1898. Built to handle crowds, to repair and maintain cars, and to change trains, this station was destined to have an interesting life—and afterlife. (Courtesy of Thomas Patton.)

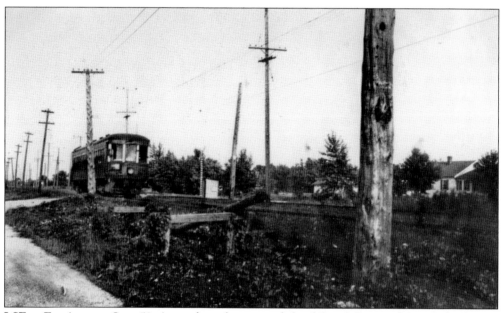

LSE AT FAY AVENUE, STOP 52. An eastbound car passes behind Gang's Store and Avon Lake Garage, likely in 1937 or 1938, which was toward the end of the LSE era. (Courtesy of Dennis Lamont.)

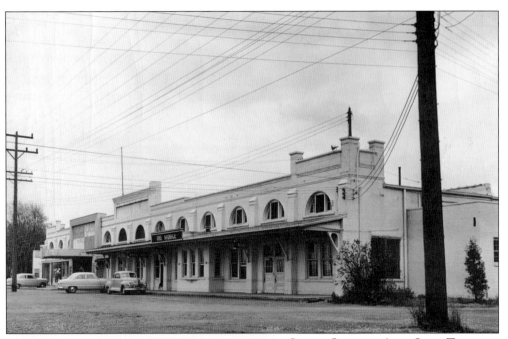

SADDLE INN AND AVON LAKE THEATER, 1949. In 1939, Cleveland entrepreneur William Frielingsdorf saw an opportunity to turn the vacant Beach Park Station and the LSE carbarn into a restaurant. The village would not allow the project to go forward unless there was a hotel, so seven rooms initially were added. (Photograph by Fred Bottomer; courtesy of CSU.)

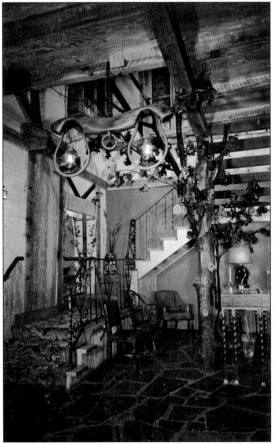

SADDLE INN'S LOBBY, 1940S. Frielingsdorf told many he called the place The Saddle Inn because his name was too long to fit on a sign. Frielingsdorf had a longtime passion for riding horses, therefore, the decor took on a Western motif. Bar stools made of saddles, including one that had belonged to Pres. James Garfield, were some of the restaurant's most memorable pieces. (Courtesy of Thomas Patton.)

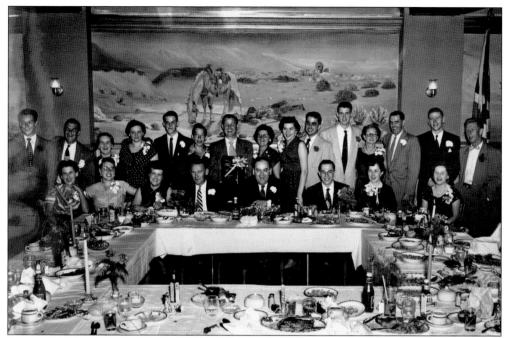

SPARKLE MARKET STAFF DINNER AT SADDLE INN, 1954. Visible are the Western-themed murals of the banquet hall, which were done by a talented Russian dishwasher/artist and his wife. (Courtesy of Josephine Scarpitti Hamilton.)

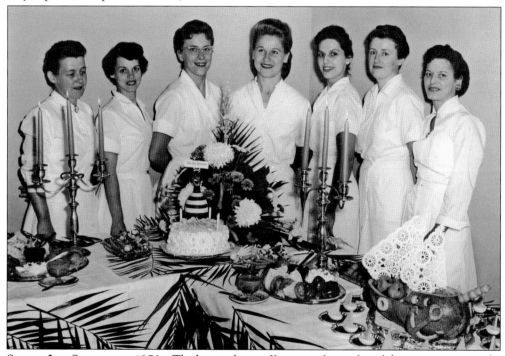

SADDLE INN STAFF, LATE 1950s. The hospitality staff poses in front of an elaborate centerpiece for a retirement party. In the center is Jean Nowak, who came to Avon Lake with her husband and two children in 1952. She later worked for the Aqua Marine Lodge. (Courtesy of Jean Nowak.)

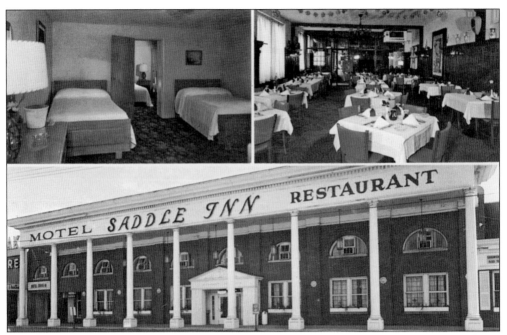

SADDLE INN POSTCARD, 1957. This shows the Saddle Inn when it was newly renovated and upgraded by Phil Tanner. On the afternoon of Sunday, September 1, 1957, a fire caused $200,000 in damage, destroying the second-floor hotel rooms. Sixteen-year-old usher, Donald Diadone, assisted 300 children out of the adjoining theater without incident by calmly announcing a routine fire drill. (Courtesy of Harvey Miller.)

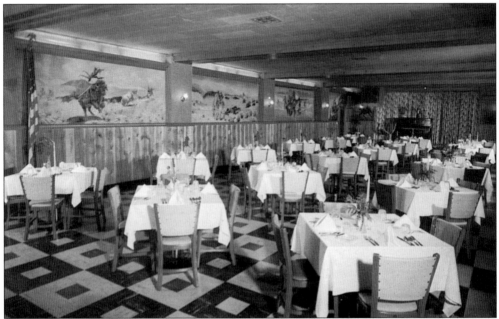

A POSTCARD OF THE DINING AREA AT SADDLE INN, 1957. Smoke and water from the fire left a mess in the dining area seen here. About 34 Kiwanians helped to clean up their regular meeting place, returning to meet here a week later. (Courtesy of Harvey Miller.)

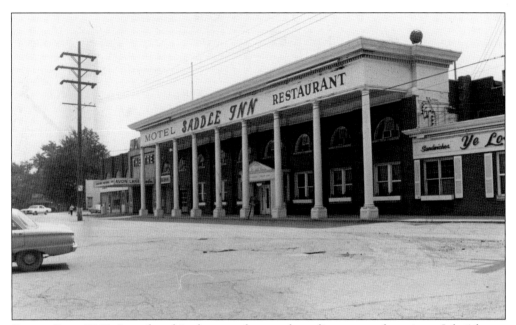

SADDLE INN, 1969. Just after this photograph was taken, disaster struck again on July 4th as a tornado tore the pillars off the front facade. The restaurant was later sold to Henry Simon, the former deli manager at Sparkle Market who ran Chef Henri's Party Center for most of the 1970s and 1980s. Frielingsdorf continued to operate the hotel until he retired in 1991. (Photograph by Fred Bottomer; courtesy of CSU.)

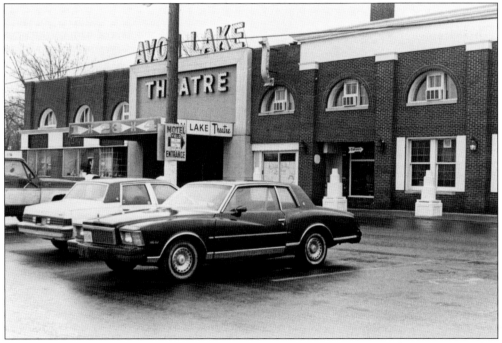

AVON LAKE THEATRE AND FORMER SADDLE INN, 1988. Note that the stubs left after the pillars were taken down remain. Avon Lake Theatre was divided into a fourplex in the late 1970s and was closed down in 1995. (Courtesy of Beverly Stives.)

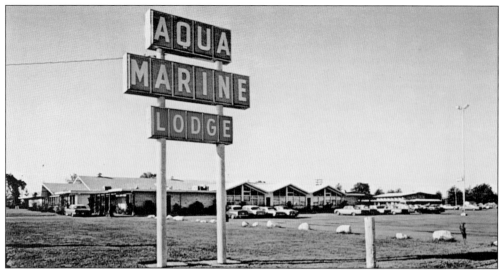

Aqua Marine Lodge Postcard, early 1960s. Ivan and Rosemary Roberts first opened the Aqua Marine Lodge in 1958 as an indoor swim and tennis club. Located on 63 acres of land west of Miller Road and just across Walker Road from the Fruehauf plant, it was promoted as an "Instant Florida" where northern Ohioans could escape the elements. Bowling and golf came shortly afterward. (Courtesy of Dan Brady.)

Aqua Marine Lodge's Interior Postcard, early 1960s. The Aqua Marine Lodge's pool featured three, large, etched- and tinted-glass windows created by local resident Francis Powell in 1961. When the Aqua Marine Lodge was demolished, these windows were returned to the Powell family from the new property owner, Kopf Construction, and the family found new homes for them. *Sunken Ship* is now on display at the old firehouse. *King Neptune* can be seen in the library's Discovery Works Department. And, unfortunately, the *Mermaid* is missing. (Courtesy of Harvey Miller.)

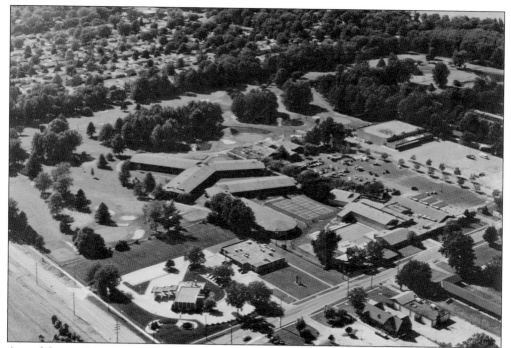

AQUA MARINE LODGE, AERIAL VIEW, C. 1980. The resort kept growing, and 50 hotel rooms were added in 1964. It eventually became a Ramada Inn with 249 units and full conference facilities. (Courtesy of Kopf Construction.)

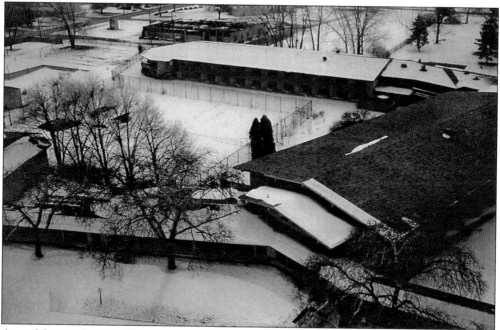

AQUA MARINE LODGE, WINTER 2000. The resort closed in December 1992. Looking southeast toward Miller and Walker Roads, one can see that the Aqua Marine Lodge has fallen into disrepair. Demolition was its fate. Today, a condominium development, also named Aqua Marine, occupies the site. (Courtesy of Kopf Construction.)

AVON LAKE SESQUICENTENNIAL, JUNE 14–22, 1969. As a nod to pioneer ancestors during the festivities, Avon Lake men were to either wear a beard or sport this "shaver permit" to avoid sanction by the "Keystone Kops." (Photograph by Kathy Diamond; courtesy of Gerry Paine.)

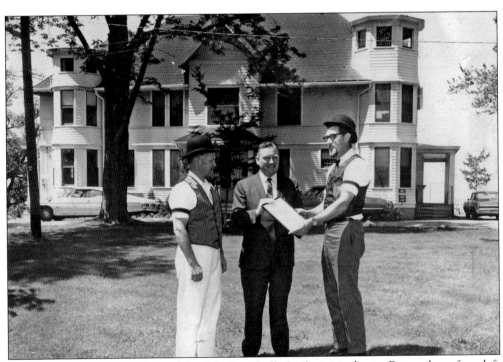

PROCLAMATION, 1969. In front of the old village hall, the festivities begin. Pictured are, from left to right, event chairman Edward R. Mitchell, Mayor John Picken, and Donald Ames, chairman of the Brothers of the Brush Committee. (Courtesy of CSU.)

SESQUICENTENNIAL PLATE, 1969. This collector's plate shows several past and present Avon Lake landmarks. (Photograph by Kathy Diamond; courtesy of Gerry Paine.)

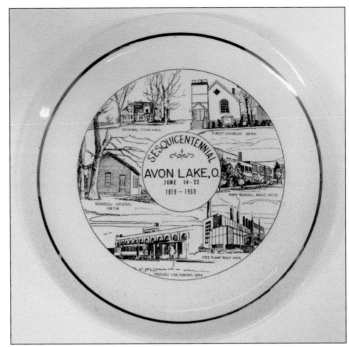

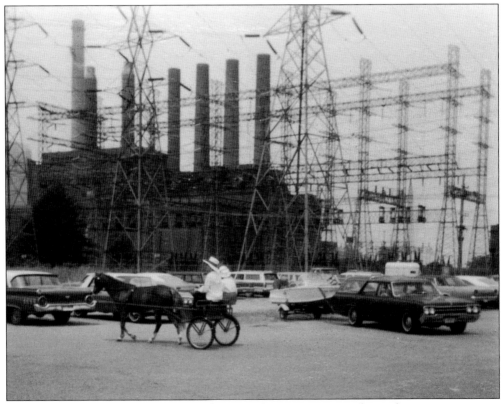

SESQUICENTENNIAL PARADE, 1969. With past and present interposed, parade participants pause in a parking lot, with CEI looming behind. (Courtesy of Josephine Scarpitti Hamilton.)

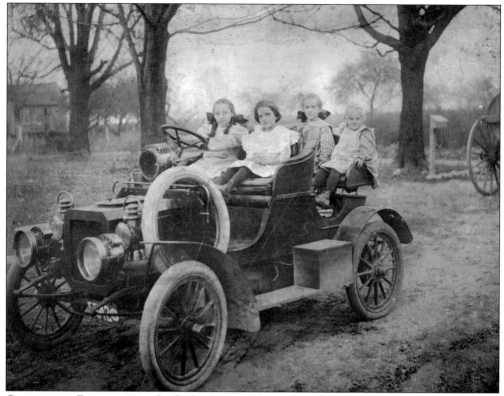

GOING FOR A RIDE, C. 1910. In the backseat of this fairly new Ford Model T are Dorothy (left) and Ruth Mitchell. (Courtesy of Gerry Paine.)

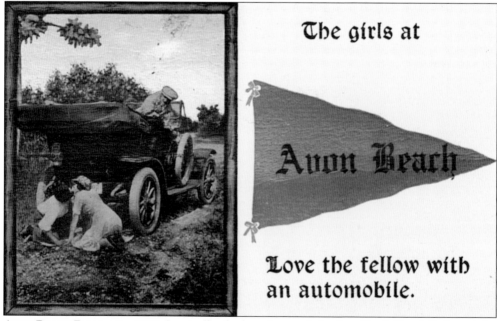

The girls at

Avon Beach

Love the fellow with an automobile.

AVON BEACH POSTCARD, 1916. Ironically, the love for cars helped end both Beach Park and the Lake Shore Electric. (Courtesy of Harvey Miller.)

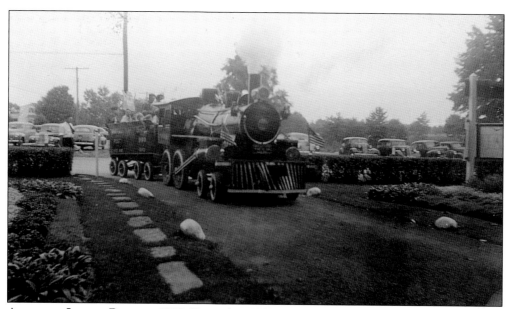

AMERICAN LEGION PARADE, 1939. Formed in 1928, American Legion Post No. 211 made their home at Park Hall until they purchased the former Walker School in 1932. Here, a parade brings a rather unusual vehicle into Park Hall's entrance. (Courtesy of John Early.)

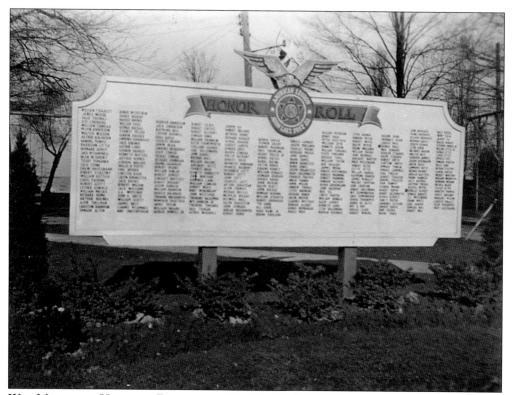

WAR MEMORIAL, VETERANS PARK, LATE 1940s. Erected by the American Legion in Avon Lake Park, this honor roll lists area residents who served in World War II. (Courtesy of John Early.)

LAKE SHORE CEMETERY, 1985. Avon Lake Veterans of Foreign Wars (VFW) Post No. 8796 parades into Lake Shore Cemetery on Memorial Day. The only cemetery in Avon Lake, it was definitely in use by 1822 but may have been used earlier, however, records are incomplete. John Robertson, who cofounded the VFW post in 1964, wanted to know how many veterans were buried here. The scrapbook documenting his research is available at the Avon Lake Public Library. It is not known who built the stone shelter and when, but it was restored and repaired by volunteers from VFW and Kiwanis in 2004. (Courtesy of John Robertson.)

GRAVE OF JOSEPH MOORE, DEATH 1848. The headstones in Lake Shore Cemetery are a who's who of Avon Lake citizens of the past. One of the oldest is for Joseph Moore, a Revolutionary War soldier who served as a bodyguard for George Washington. He was the father of Hannah Moore, who became Mrs. Anson Titus. In 2002, the VFW placed 12 more markers for veterans, like the one shown, in the cemetery. (Courtesy of Gerry Paine.)

Avon Lake Heritage Quilt, 1991. Depicting places and symbols of Avon Lake's past, the idea for this quilt was first presented at the 1990 high school and community homecoming festival by Debra Beard and Sue Gerbick. By January 1991, a total of 17 people submitted blocks for the quilt, which was then assembled by the Avon Lake United Church of Christ in time for the 1991 homecoming celebration. It is on permanent display at the Avon Lake Public Library. The project echoes a similar one completed for homecoming in 1982—Betty Blakemore's "Avon Lake: a Montage of Memories" also on display at the library and in many homes. (Courtesy of Avon Lake Public Library.)

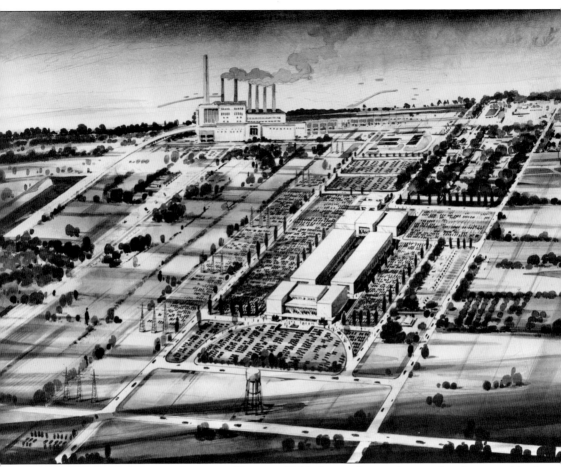

PROPOSED NORTHGATE SHOPPING CENTER, 1959. Just as fascinating as what happened is the following question: "What might have happened?" Plans that are proposed and disposed of are often forgotten. First, this $7.5-million project proposed by William Frielingsdorf would have expanded his shopping center on Lake Road all the way south to Walker Road and included parking for 6,000 cars. (Illustration by George S. Voinovich; courtesy of CSU.)

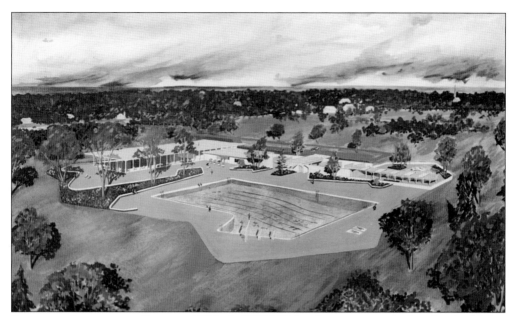

PROPOSED COMMUNITY CENTER, 1956. A $500,000 bond issue was considered to build this combination community building and swimming pool designed by Dalton and Dalton, architects. (Courtesy of CSU.)

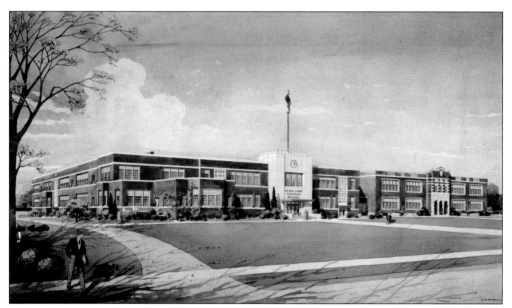

PROPOSED SCHOOL ADDITION, 1946. Here is an architect's rendering of a proposed $995,000 addition to Avon Lake School. This issue was defeated, but a $750,000 issue for updates and building decentralized facilities passed in 1950, so today's high school looks quite different. (Illustration by E.D. McDonald; courtesy of CSU.)

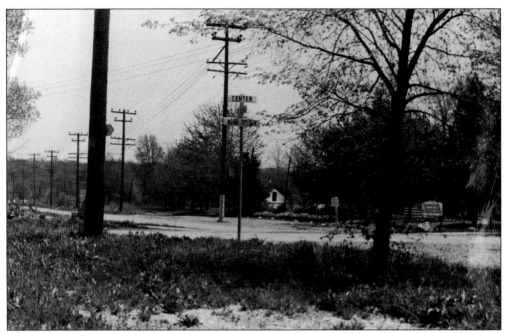

CENTER ROAD AND ELECTRIC BOULEVARD, C. 1948. This view is looking southeast from the future site of the Municipal Building, with parking for Burmeister's Funeral Home in the center. Note the street sign uses both "Center" and "Avon Belden." (Courtesy of William Burmeister.)

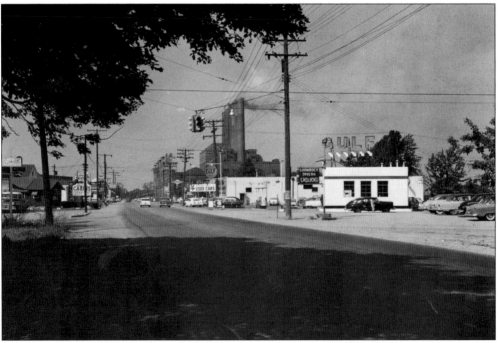

LAKE ROAD, 1956. From Stop 63 and looking west, here is a view of Avon Lake's strip at its peak. With several stores, gas stations, restaurants, cabins, motels, taverns, and banks, the former Beach Park, also known as "Saddle area" and (more officially) as Avon Lake Shopping Center, was the unofficial downtown of Avon Lake. (Courtesy of the City of Avon Lake.)

HENRY CABOT LODGE CAMPAIGN VISIT. The vice-presidential candidate on the Nixon ticket, Henry Cabot Lodge, stopped by the Saddle area for a preelection visit on October 27, 1960. It was rumored that John F. Kennedy stayed at the Saddle Inn, but according to Frielingsdorf, it was actually Eunice Kennedy Shriver. (Courtesy of Josephine Scarpitti Hamilton.)

SAFETY TOWN, 1967. A summer program that was a true partnership of the PTA, schools, and safety forces, Safety Town was held at Erieview from its inception in 1964. It later moved to Westview School and became a Kiwanis project. (Courtesy of Avon Lake Parks and Recreation.)

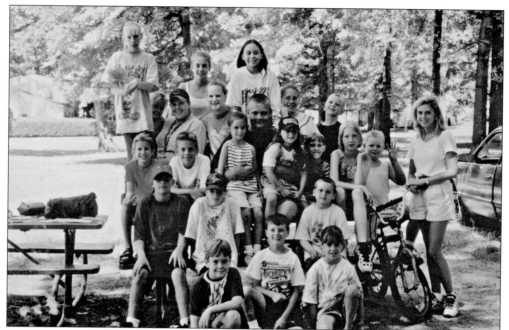

GREENBOX GANG, 1998. Since the 1950s, large green boxes are located within each Avon Lake park all summer long. Supplies for arts and crafts, games, drama, and other programs to engage the young are kept here, brought out by volunteer neighborhood moms at first, then by paid students. Here, Greenbox supervisor Lori Foutz (far right) is seen with a group at Redwood Park. (Courtesy of Avon Lake Parks and Recreation.)

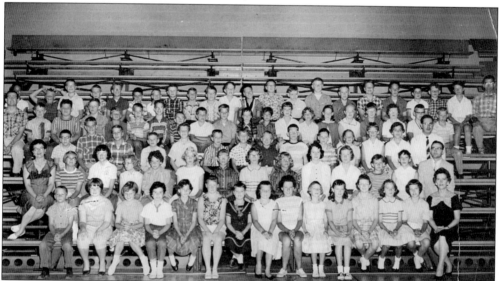

FIRST SUMMER ENRICHMENT PROGRAM, 1959. Elementary students from public and parochial schools in Avon Lake were invited to be a part of the Summer Enrichment Program and given direct experience with meteorology, literature, science, radio, and electronics. Field trips and guest speakers, such as *This Is Ohio* author and *Cleveland Plain Dealer* writer Grace Goulder, were memorable, and the business community fully participated and supported it. (Courtesy of Nancy Abram.)

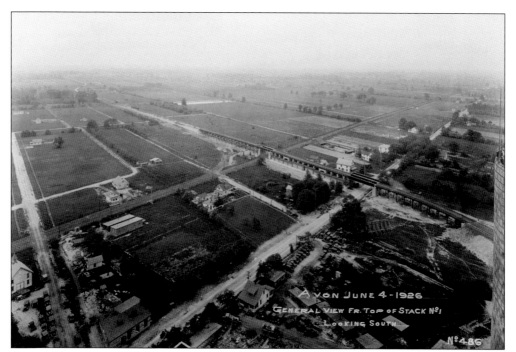

AERIAL VIEW FROM CEI STACK, 1926. Looking southwest, one can see, starting from the left, Avondale Avenue, the bridge over LSE, and Lake and Miller Roads in the medium distance. (Courtesy of GenOn, Inc.)

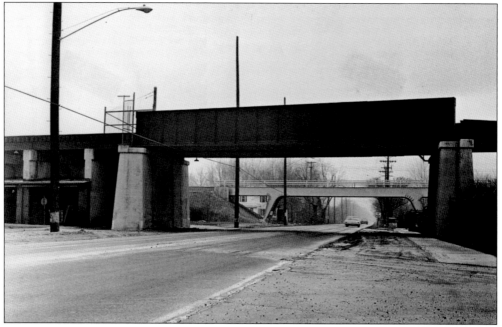

TWO RAIL BRIDGES OVER LAKE ROAD, 1967. The 1925 bridge (in the foreground) was twinned with a new bridge to bring coal to the plant. The old bridge was removed shortly afterward, and the new bridge, with a span permitting future widening of Lake Road, remains today. (Courtesy of CSU.)

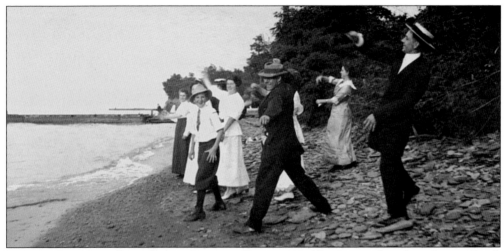

SKIPPING STONES AT DUFF BEACH, LOOKING EAST, 1910. The boy in the white shirt is Frank Naylor, the woman in white is Hattie Beard, and the man in a dark suit and hat on the left is Glenn Beard. (Courtesy of Debra Beard.)

DUFF BEACH, LOOKING WEST, 1955. Barbara Jones skips stones at Duff Beach; the breakwater for the CEI plant is seen in the background to the west. (Courtesy of Barbara Klingshirn.)

STEREOGRAPH, C. **1910.** Here is a view of Beach Park, looking east from near the present-day Miller Road Park boat launch. (Courtesy of Richard Walz.)

BIBLIOGRAPHY

Abram, Nancy Nelson. *Avon Lake: A Journey in Time*. Vol. 1. Avon Lake, OH: self-published, 1999.
Abram, Nancy Nelson. *Avon Lake: A Journey in Time*. Vol. 2. Avon Lake, OH: self-published, 2007.
Atlas and Directory of Lorain County. Cleveland, OH: American Atlas Company, 1896.
Dempsey, Vincent. *Cabin Boy*. New York: Coward-McCann, 1956.
Ennis, Winifred. "History of Avon Lake, Ohio." Unpublished typescript, 1941.
Koff, Lois Ann and Marian Quinn. *Faith, Joy & Tears: The Klingshirn Saga Continues*. Avon Lake, OH: Westfair Publishers, 1984.
Lake, J.D. *Atlas of Lorain County, Ohio*. Philadelphia: Titus, Simmons & Titus, 1874.
Patton, Thomas J., Dennis Lamont, and Albert Doane. *Lake Shore Electric Railway*. Charleston, SC: Arcadia Publishing, 2009.
Robertson, John. "Avon Lake Cemetery." Unpublished scrapbook, 2002–2008.
Walker, Milburn. *The Avon Lake Story*. Avon Lake, OH: Avon Lake Kiwanis Club, 1965.

There are many stories and special sections from the following periodicals:
The *Cleveland Plain Dealer*
The *Cleveland Press*
The *Elyria Chronicle*
The *Lorain Journal*
The *Press* (Avon Lake)

More about the History of Avon Lake

This book was not the beginning, nor is this page the end.

Avon Lake Public Library (www.alpl.org) has everything listed in the bibliography, as well as many more items, including the following: newspaper clippings filed by topic, reports, studies, and council meeting minutes; city directories by various publishers (1941, 1952, 1957, 1960, 1969 to the present); Avon Lake High School yearbooks (*Shore Log*, 1960 to the present); The *Press* and earlier area newspapers on microfiche and searchable, scanned PDFs (mostly from 1981 on); and, coming soon to the library, indexed obituaries.

Many of the photographs in this book—as well as hundreds that we did not have room for—can be seen online at the Cleveland Memory Project (www.clevelandmemory.org/avonlake). Staff and volunteers are diligently uploading pictures and descriptive information. You can also read Milburn Walker's book, *The Avon Lake Story*, here.

We welcome your comments, suggestions, and corrections. We also welcome your loans or donations of photographs, postcards, and other artifacts of local interest.

Become a Friend of Avon Lake Public Library by clicking on the link on our website.

The Avon Lake Historical Society meets the second Monday of each month at the Avon Lake Public Library at 1:00 p.m. There are guest speakers, discussions, special projects, field trips, and a holiday luncheon. Membership is $10 per year.

You may also want to join and support the Peter Miller House (P.O. Box 62, Avon Lake, Ohio 44012) and the Thomas Folger Home (Avon Lake Landmark Preservation Society, 32770 Lake Road, Avon Lake, Ohio 44012, www.folgerhome.org).

"Avon Lake Life" is an ongoing oral history project of the library and Avon Lake Community Television. DVDs of recent interviews with over 40 longtime Avon Lake residents are available to check out, and most are indexed by subject and time code. Contribute your memories or dig through what we have. Classic interviews, documentaries, and events from the past two decades are also available. If you really want to explore, ALC-TV has decades' worth of programming digitally stored and indexed. See many recent programs at avonlake.pegcentral.com.